SHREWSBURY

THROUGH TIME
Dorothy Nicolle

AMBERLEY PUBLISHING

Acknowledgements

I think my first acknowledgement must be to those many stallholders in antiques fairs who show endless patience as I trawl through their boxes of Shropshire cards, not allowing any other potential customers near until I've had my first look. I would also like to thank Shropshire Museums for their help, particularly when I wanted the 'building site' photograph of the new museum in the Music Hall. Finally, but by no means least, I want to thank all the team of Shrewsbury town guides for their generosity in sharing stories. Over the years I've learnt so much from them, sometimes it's more than I can take in, sometimes it's just a snippet of information or an amusing anecdote. This book is as much theirs as it is mine.

First published 2013

Amberley Publishing
The Hill, Stroud
Gloucestershire, GL5 4EP

www.amberley-books.com

Copyright © Dorothy Nicolle, 2013

The right of Dorothy Nicolle to be identified as the Author of this work has been asserted in accordance with the Copyrights, Designs and Patents Act 1988.

ISBN 978 1 4456 0811 2

British Library Cataloguing in Publication Data.
A catalogue record for this book is available from the British Library.

Typeset in 9.5pt on 12pt Celeste.
Typesetting by Amberley Publishing.
Printed in the UK.

Contents

Introduction

Collecting old postcards is an absorbing hobby and most of the old pictures in this book come from my own collection of early cards and prints. Collectors of Shrewsbury postcards are particularly fortunate because of the existence in the late 1800s and early 1900s of a postcard-producing company, Wildings, in the town. Wildings didn't just produce photographic cards but also employed a number of local artists who painted a series of cards that are now extremely collectable. Many of these painted cards are somewhat romanticised but they are still very evocative of life in the time they portray.

Usually, when presenting photographs in a book of this sort, the pictures are arranged so that the reader can follow a virtual route around the region or town. Shrewsbury, however, has so many old buildings with fascinating stories to tell that I decided, instead, to trawl through its history in pictures so that, occasionally, the same places appear at different times in the town's story.

And what a wonderful story it is, too. When the Normans arrived soon after 1066 they found a town that was already a well-established administrative centre with trading links throughout both England and Wales. That early market town thrived so that by 1300 or so it was one of the dozen most important and wealthy towns in England, despite regular incursions from the Welsh just over the nearby border.

It was the wool trade that made Shrewsbury so successful and this success is evident in the many fine timber buildings. Most of these were built by drapers or woollen cloth merchants and, when you consider how some of the largest and finest of them date from the late 1500s, a time when timber was becoming more and more expensive, one needs little reminding of the extreme wealth these people had.

By Victorian times Shrewsbury's importance was being overtaken by newer conurbations growing in industrial areas elsewhere, but in a sense this was fortunate since the heart of the town did not suffer massive redevelopment. Inevitably we have lost a number of fine buildings over the years but, despite this, Shrewsbury has retained a charm that is second to none. Enjoy exploring the town through the pictures in this book and then, please, take the first opportunity you have to explore the town for real. You won't be disappointed.

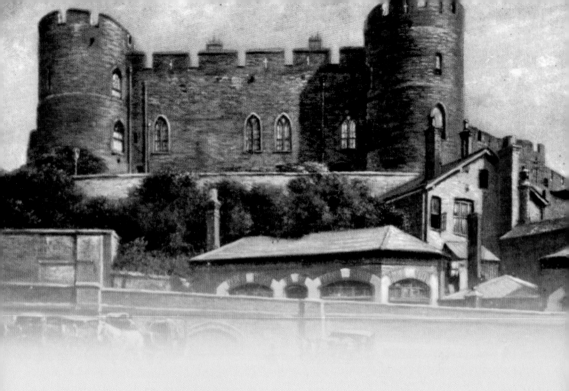

CHAPTER 1

Early Days

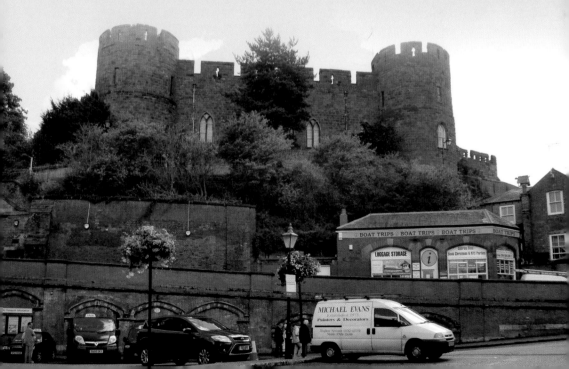

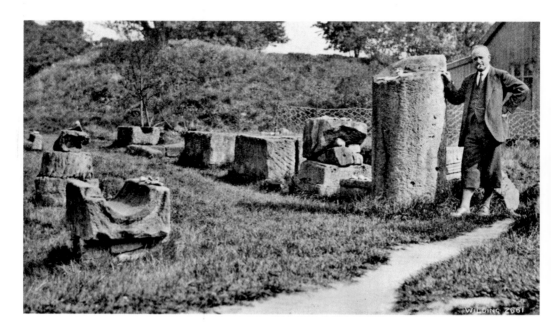

Wroxeter

Long before there was a county called Shropshire the first town in the area was built by the Romans in the second century AD. It's difficult to believe, when you see what remains of the ruins today, that Wroxeter (or Viroconium as it was then known) was the fourth largest town in all of Roman Britain. After being abandoned, probably sometime in the sixth century, the site was never subsequently developed and was used primarily as a source of building stone in the centuries that followed for local churches, as has happened at nearby St Andrew's church. Excavation in the archaeological sense began in the 1800s.

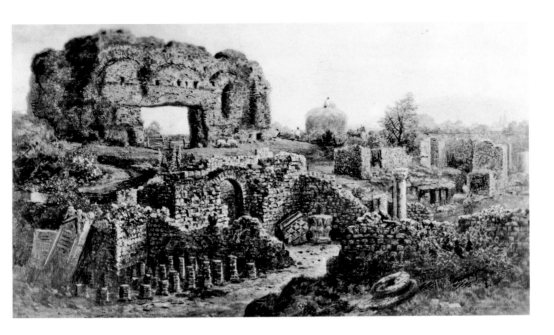

Wroxeter – The Old Work

This somewhat romanticised view of Wroxeter shows the former bathhouse with the sturdy brick pillars for its hypocaust heating systems. A comparison with the modern photograph gives an indication of just how much stonework has been removed in the interim, not to mention the inscribed and decorated stone in the left foreground.

Today the site is deliberately left undisturbed for future archaeologists so that the only agricultural activity allowed is the grazing of sheep. However, in the background of the early picture it is possible to make out a horse-drawn cart piled high with hay or corn that has just been cut.

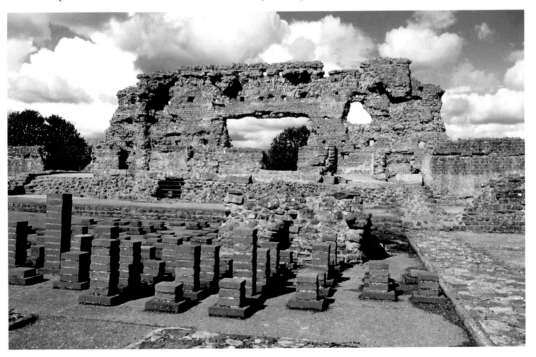

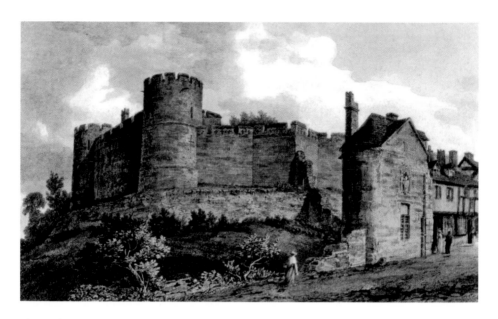

Shrewsbury Castle

The town of Shrewsbury was already well developed in Saxon times, but little of that town survives today, although the street plan is a reminder of how that early town was laid out and developed. The arrival of the Norman conquerors soon after the Battle of Hastings saw sudden development. For a start the Normans needed to build a castle from which they could subdue and control the recently defeated English and, in so doing, they destroyed some fifty houses (which can't have helped their popularity). The view above is from a print that probably dates from the 1700s.

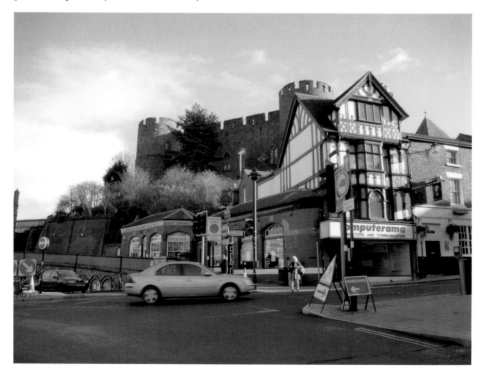

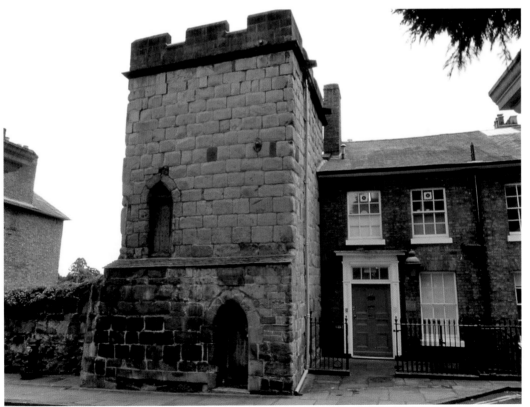

Tower on Town Walls

As a border town protecting England's interests on the English-Welsh border, Shrewsbury was regularly attacked by marauding Welshmen. Consequently, in the 1300s protective stone walls were built all around the town with towers spaced at regular intervals along it. This tower, on a street appropriately named Town Walls, is the only one that survives. I always assumed that the lean of the tower in towards the road was the result of twentieth-century traffic using the road. It's interesting to note that that lean was already very pronounced 100 years ago.

Town Wall, Shrewsbury.

E.A.Phipson

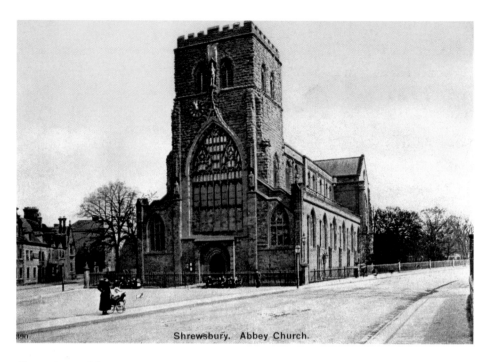

Shrewsbury. Abbey Church.

Shrewsbury Abbey

Following the Conquest William doled out large parcels of land to his followers. Shropshire thus came into the hands of Roger de Montgomery. The story goes that his clerk, a man called Odelirius, had been so impressed by abbeys he had seen in Europe that he persuaded Roger to establish one in Shrewsbury. There was already a little wooden church on the site and it was into that building that Roger went, laid his gloves on the altar and dedicated it, in 1083, to become an abbey. Notice the iron railings in the postcard – these were removed during the Second World War.

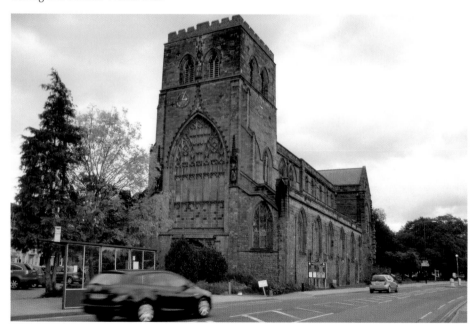

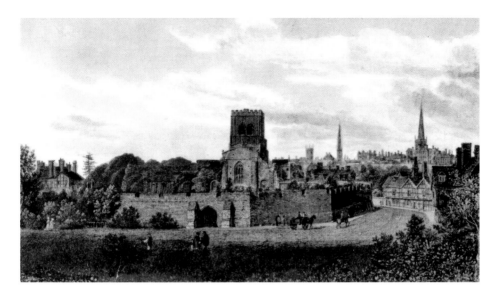

Shrewsbury Abbey from the East

Believe it or not, this is almost the same viewpoint – note the church spire on the right of the photograph, behind the 'No Entry' sign. When the illustration above was produced around the turn of the eighteenth and nineteenth centuries, the old monastic walls were still in evidence. These were to be destroyed soon afterwards when a new road was laid that smashed right through a section of the wall and the cloisters on the southern side. This was the London to Holyhead Road and many today feel that Thomas Telford, who surveyed the route, was a vandal to do such a thing. But never judge history using your modern opinions – no one cared for such ruins then and this new route did away with two sharp bends that impeded the stagecoaches.

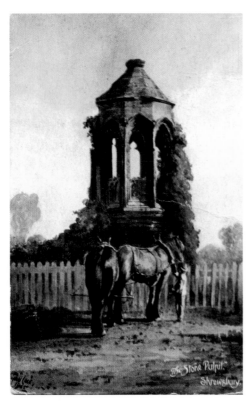

The Old Pulpit

Thomas Telford did, however, preserve the pulpit that still stands across the road from the church. This may sound strange until you realise that this pulpit has never been moved and was never in the church; it was a refectory pulpit and still stands where the dining hall once was. From here one monk would have read the Scriptures aloud to his fellows whilst they silently ate their meals.

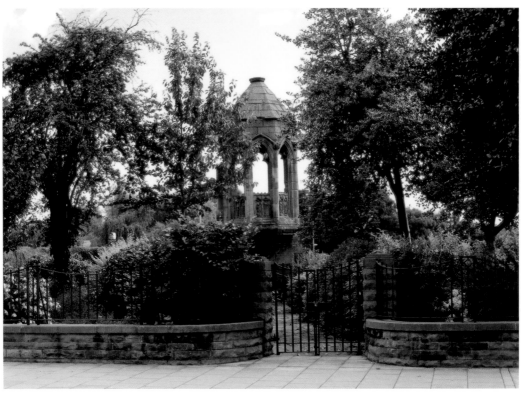

Shrewsbury Abbey

We are fortunate that anything survives today of the former Shrewsbury Abbey. This came about because, throughout its life, the western end of the building served as a parish church. Consequently, when the abbey was dissolved in the 1500s, the end near the tower, which we see here, was left alone when the eastern end (the monk's end) was destroyed.

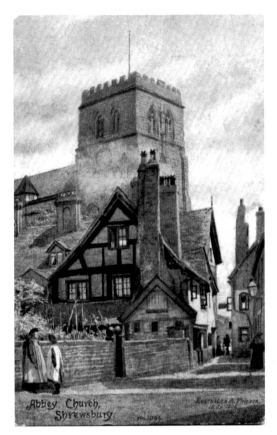

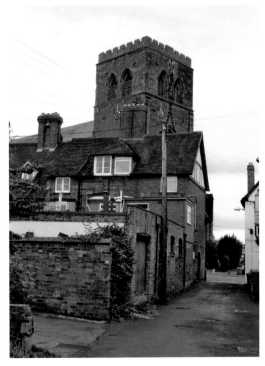

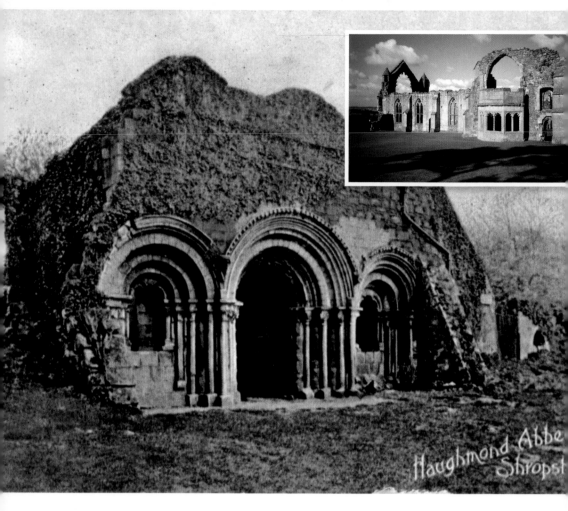

Haughmond Abbe
Shropst

Haughmond Abbey

In the centuries that followed the Norman invasion several religious orders set up houses in and around Shrewsbury. One, just outside the town, was the Augustinian order, which established an abbey below nearby Haughmond Hill. When the abbey was dissolved in the 1500s some of it survived as a private house until the mid-1600s when it was destroyed by fire. Pictured above is the chapter house.

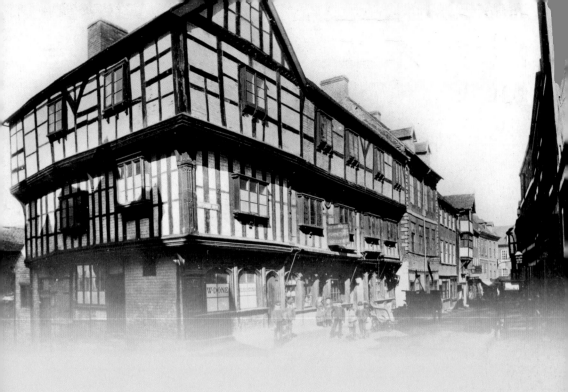

CHAPTER 2

Medieval Shrewsbury

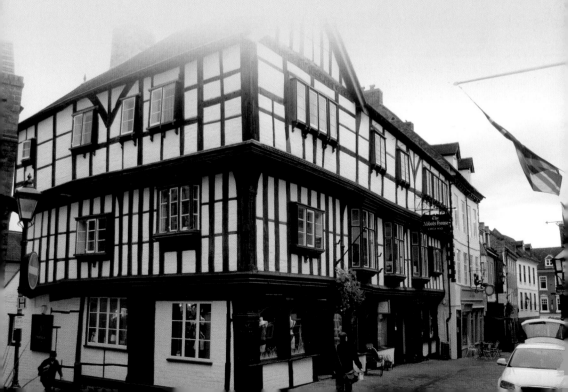

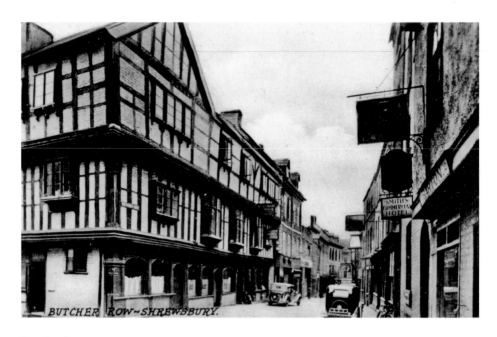

Butcher Row

Street names in the past always told you what you would find in them – this, therefore, is obviously where you would have come to buy your meat. With the cattle being slaughtered in the street and then butchered immediately the mess and stench here must have been indescribable. The Abbot's House, as the building on the left is called, has recently had its timbers dated. Since medieval carpenters used green timber when they constructed buildings, we can therefore assume that the building itself dates from the late 1450s.

Looking Down Butcher Row
Notice the way in which buildings on both sides of the street jut out, each floor reaching a little beyond the floor below. This is a regular feature of buildings of the time and is known as 'jettying', just as a jetty on a quayside reaches out over the water.

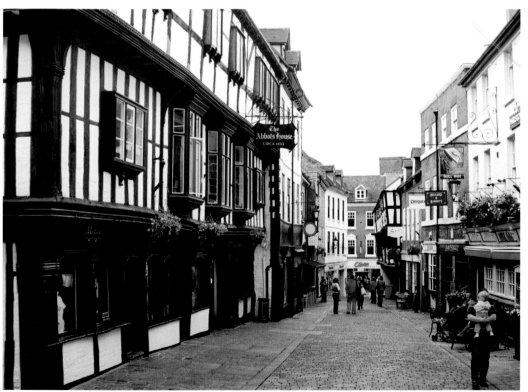

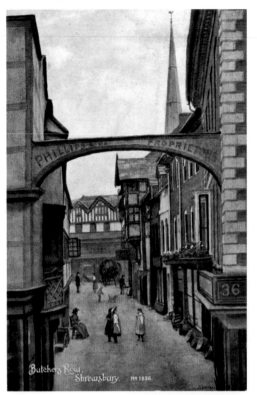

Looking Up Butcher Row

This is the same street, seen in the opposite direction. The building at the end of the street was pulled down at the end of the 1960s, a period that saw the disappearance of many fine old buildings all over the country. Here in Shrewsbury we were relatively lucky. Certainly quite a few buildings were destroyed (many being replaced by modern monstrosities) but, by and large, the fashion for destruction stopped before too much damage was done.

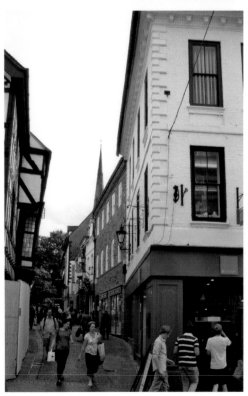

Fish Street

I often describe Bear Steps (the name given to the building on the left) as the building that saved Shrewsbury. A section of it had already been pulled down when people in the town suddenly realised what a treasure they were demolishing and stepped in to save the rest of the building. From then on greater care was taken not only to preserve the town's heritage but, as you can see here, to restore it to its former glory.

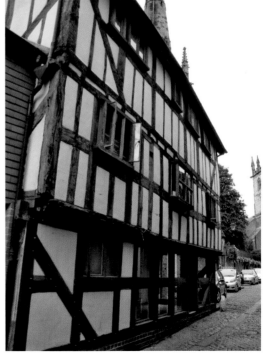

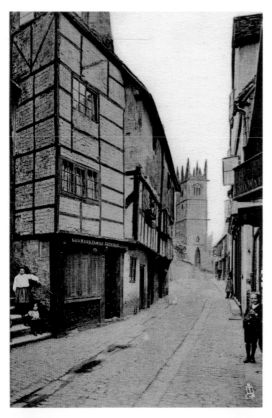

Fish Street

It's the steps on the left that give the building of Bear Steps its name. The name has nothing to do with animals; instead The Bear was the name of a pub that once occupied the site on the right. Notice the little house immediately beyond the steps – this was used in a 1980s film version of *The Christmas Carol* when it featured as the entrance to the home of Bob Cratchet and his son, Tiny Tim.

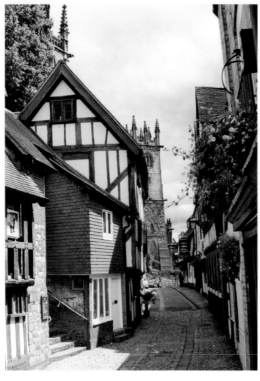

Grope Lane from the Square
So much of Shrewsbury seems like a
potential film set for 'olde worlde' settings
and the only way to get a true feel for
the place is to wander up and down all
the streets, taking care not to miss any of
the old shuts. A shut is a local term for
a narrow alleyway that links two main
streets and there were once around 200 of
them in the town.

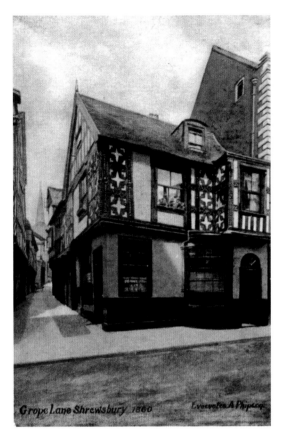

Grope Lane Shrewsbury 1860 Evecvelen A Phipcq:

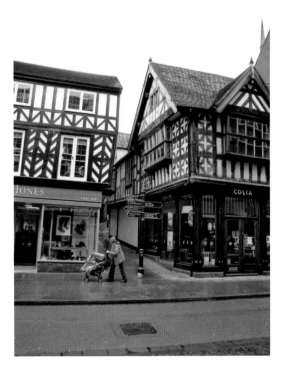

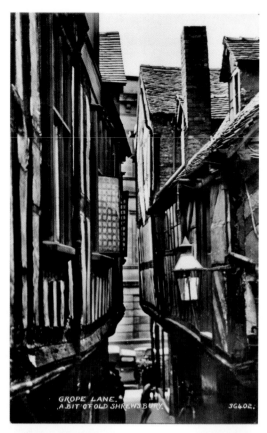

Grope Lane

If you laugh when you learn that the name of this shut is Grope Lane then you probably have the correct interpretation of the name. Situated between two market areas this would have been an ideal spot for the local harlots of old to tout for business! It's also a fascinating place for people today to linger – but in their case they are probably admiring the carpenters' marks on the timber building on the left.

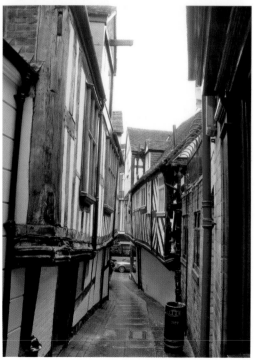

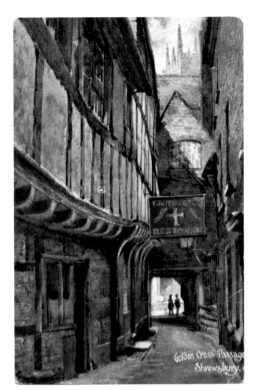

Golden Cross Passage

Another little shut but this time not with such a dubious reputation. Instead it is named because of its proximity to Old St Chad's church and the pub on the left, the Golden Cross, would have accommodated visitors to the church. It's said to be the oldest pub in the town, dating from 1428, and is haunted by a monk.

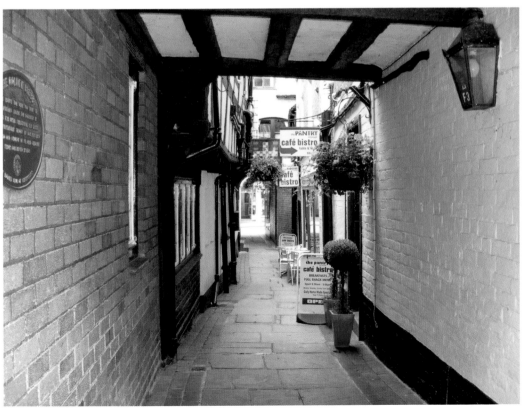

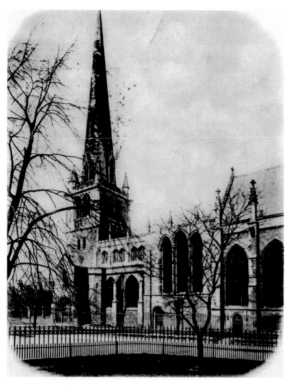

St Mary's Church

This postcard in my collection is dated 1902 and the writer says of St Mary's that 'it is very beautiful inside'. The architecture is a wonderful mishmash of styles through many periods that gives the church its charm; but the true treasure of the church is its collection of stained glass, dating from medieval to Victorian times and with examples not just from England but from many parts of Europe, too.

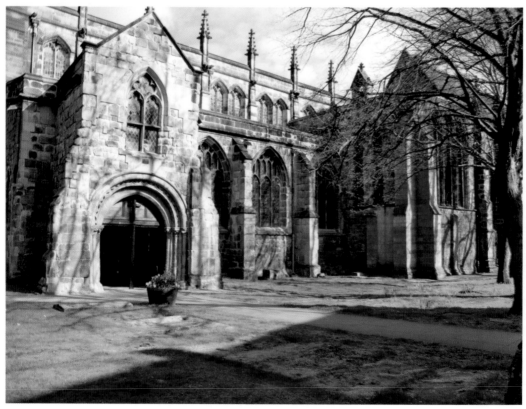

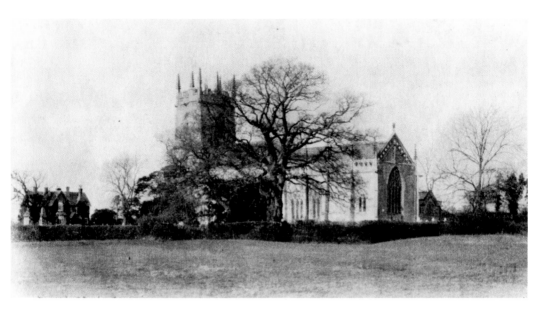

Battlefield Church

The year 1403 saw, just to the north of Shrewsbury, a battle that lasted for some three hours and left around 6,000 men dead or dying. It was fought by the rebel Harry Hotspur against King Henry IV, and this church was built on the orders of the King as a memorial to all those who died.

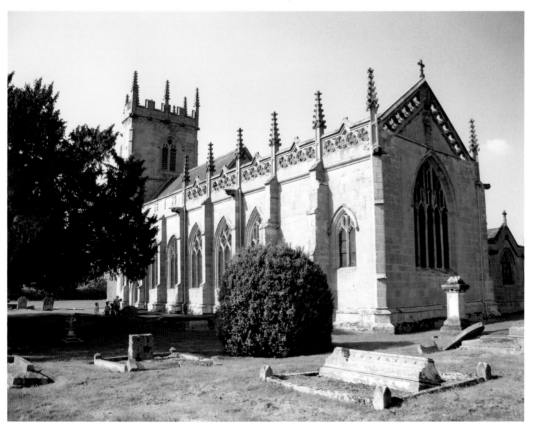

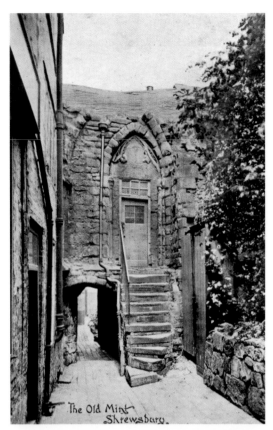

The Old Mint
Shrewsbury.

The Old Mint

There are many modern buildings in Shrewsbury that sit on much older foundations, sometimes even incorporating the old architectural features in the later structure. And, occasionally, one can see examples of this without having to delve into the old cellars. One particularly pleasing example of a mix of the old and the new is to be found in Banks at the bottom of Pride Hill.

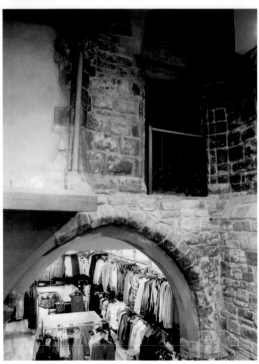

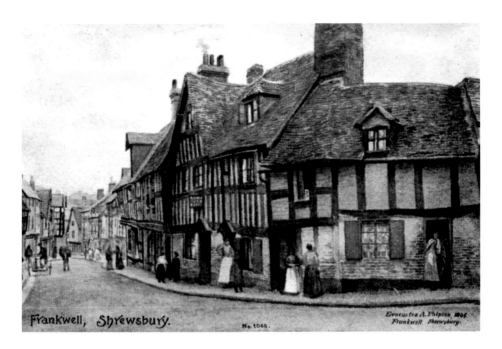

Frankwell, Shrewsbury.

The String of Horses, Frankwell

Not all old timber-framed buildings that are pulled down are totally lost. The old String of Horses public house that used to sit where all the traffic now circles the new Frankwell roundabout was taken to the Avoncroft Museum of Historic Buildings in Bromsgrove, where it now serves as the reception for the museum.

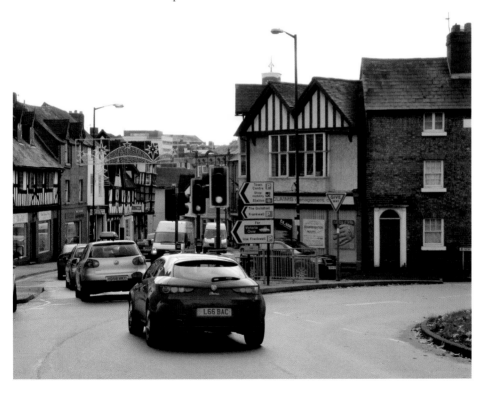

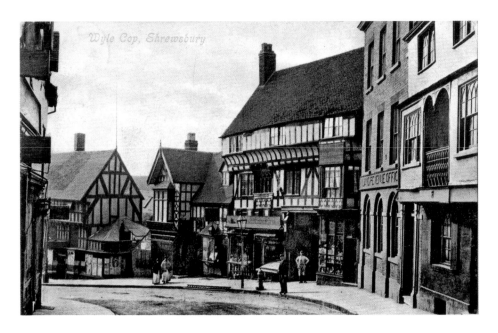

Henry Tudor House

Henry Tudor House near the top of Wyle Cop is so-called because Henry Tudor stayed there on his way to meet with Richard III on Bosworth Field. Apparently, when Henry and his army arrived in Shrewsbury and demanded to be let into the town they were first met with a refusal by the then provost of the town, Thomas Mytton. Mytton stood up and announced that he supported Richard and Henry Tudor would enter the town 'only over my body'. The frightened townspeople told Mytton that he had to let Henry come in for fear of the damage he would cause if there was a fight. Mytton was persuaded to lie down on the bridge, enabling Henry to enter 'over his body'.

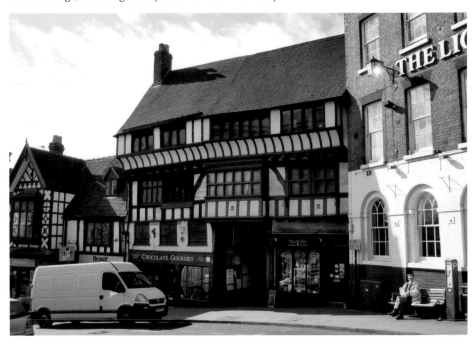

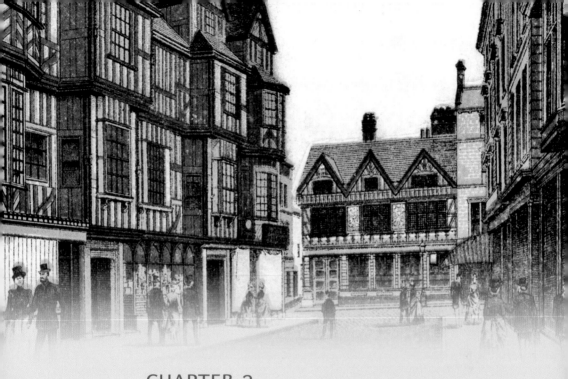

CHAPTER 3

Tudor & Stuart Shrewsbury

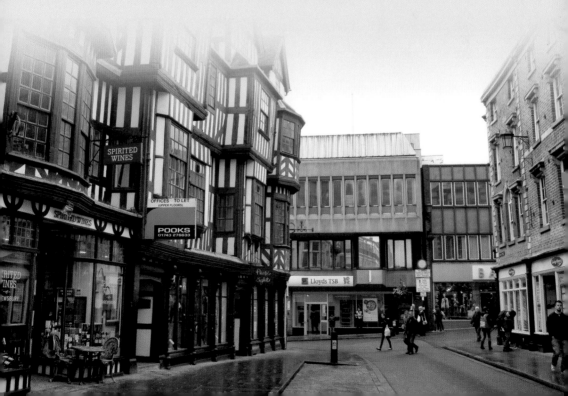

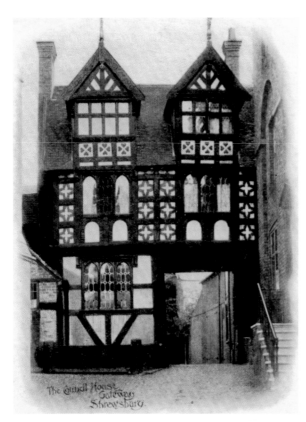

The Council House Gatehouse
The unification of England and Wales under the Tudor monarchs saw many changes to the Marches (or Border) region. For a start both countries came under a single system of administration and law. The Gatehouse, pictured here, sat at the entrance to the Council House where the law courts were held. It is said that this building was also used for the temporary imprisonment of prisoners whilst they were attending court cases.

The Council House Gatehouse from the Yard

It's often the case with timber-framed buildings that they are covered with decoration on the side that faces onto the street whilst the rear is kept relatively plain – you don't waste expense on decorative features that no one can see. Here, of course, with visiting bigwigs coming to the Council House, it would have been important to have decoration on both sides of the building.

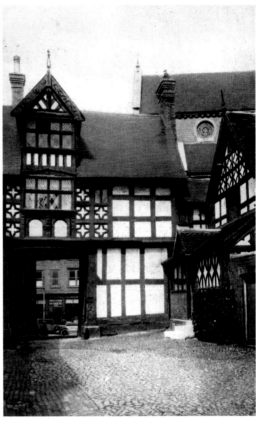

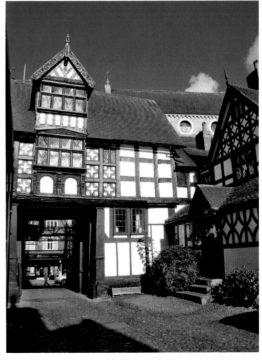

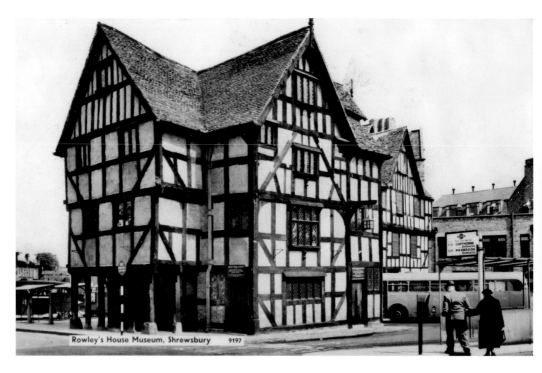

Rowley's House Museum, Shrewsbury 9197

Rowley's House Museum

As I write this, the life of the museum in Rowley's House is soon to come to an end – it is intended that it will move to the Music Hall in the Square sometime during 2013. A decision will then have to be made about what to do with the building. Studying the recent photograph (taken of the other side some years ago, from a multistorey car park that has since been demolished) you will see that it is a building in two parts with a sixteenth-century timber section and a brick addition that was added a generation later.

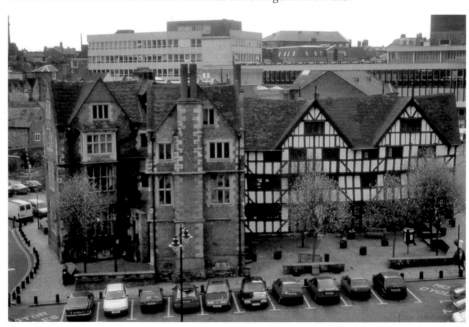

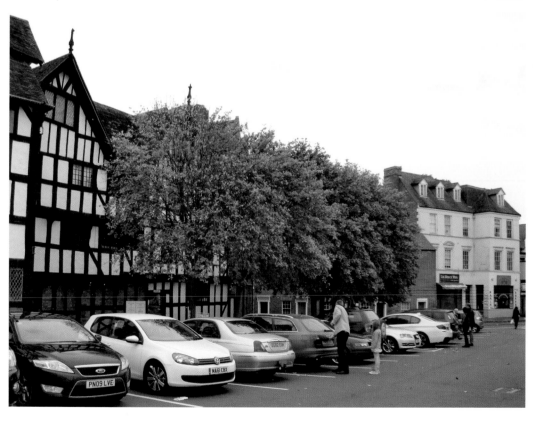

Rowley's House and the Old Ship Inn

One hundred years ago Rowley's House sat in the midst of a warren of old buildings, narrow streets and alleyways. The latter were all cleared away (including the Ship Inn pictured here) so that today the house sits proud. It seems strange to us that someone who was obviously wealthy enough to build such a large house would have chosen a site like this but, of course, all merchants in those days would have lived where they worked.

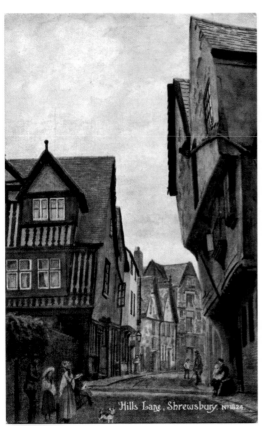

Hills Lane, Shrewsbury. No 1824

Hill's Lane

Perhaps the best point of reference connecting these two pictures is the brick gable of Rowley's House at the far end of the street. Jonathan's, the shop on the left, has had several facelifts over the years. When the last one was done (in the 1980s) it was discovered that the building had three front walls, one on top of the other, as different generations had redesigned it.

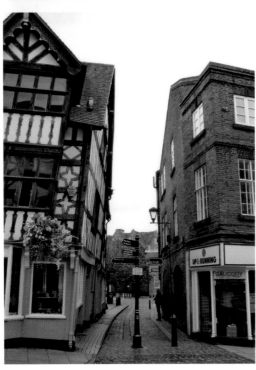

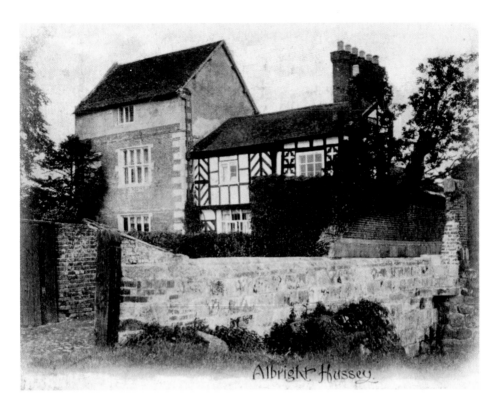

Albright Hussey

Another building that, like Rowley's House, has an earlier timber frame with a brick addition is Albright Hussey, just to the north of the town. This is now used as a hotel with all the main reception rooms giving a wonderful olde worlde aura. The bedrooms, however, have all the modern facilities you could hope for!

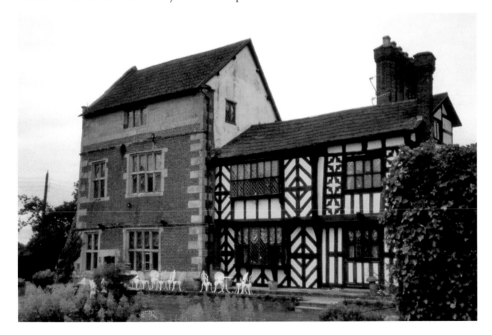

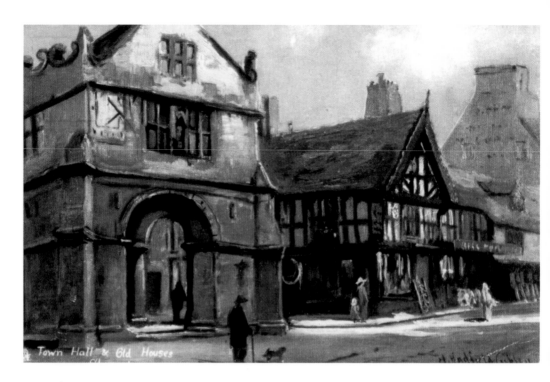

Town Hall & Old Houses

The Square

One timber building that has not survived, however, is the one pictured here where, nowadays, the job centre sits. To the left is the old market hall. It, too, has had a chequered history. At first it served as a market, the upper floor being the local drapers' or woollen cloth merchants' market. In recent years the upper floor has been used as a courtroom and today it is home to a coffee shop and a cinema.

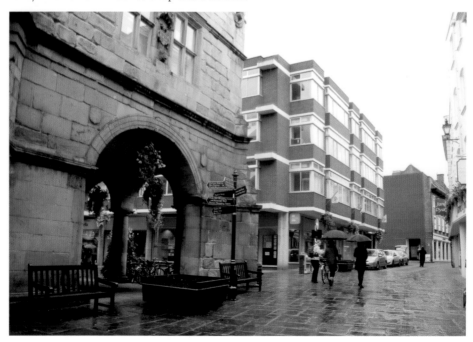

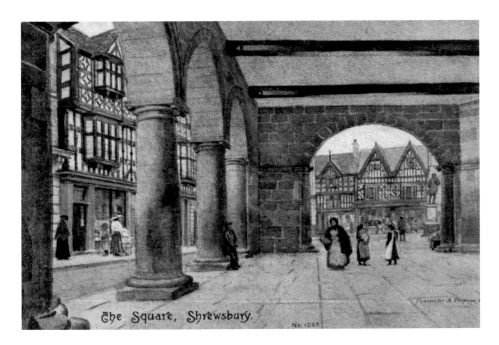

The Square, Shrewsbury.

No. 1087.

The Square

The ground floor of the old market hall is typical of market halls of the period, in that it is an open arcaded area giving protection from the weather. What isn't so typical is the Tuscan-style columns and the use of top-quality Grinshill stone in its construction. The building dates from 1596, a period when you see the beginnings of a changeover from timber to stone in many public buildings in the region.

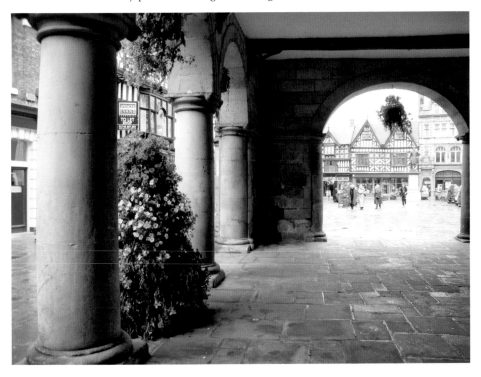

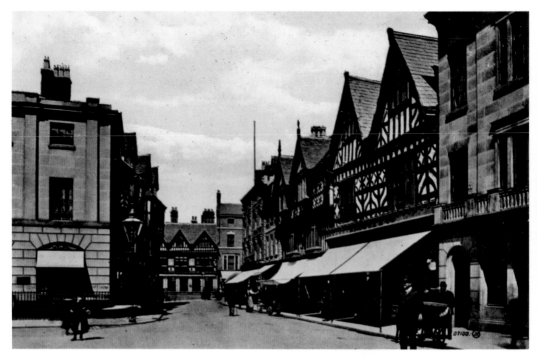

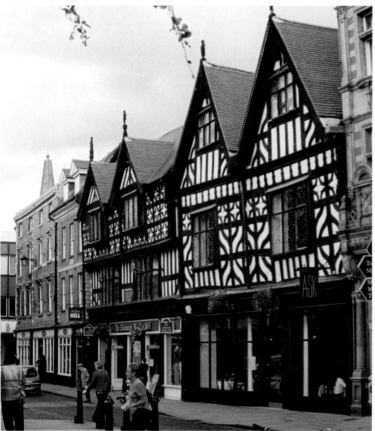

The High Street

In this photograph I love the way all the blinds are pulled down to shade the products on display in the shop windows. The beautifully decorated timber building is Owen's Mansion and dates from the 1580s. Notice how, on two gables in the earlier picture, there are little carved figures. Carvings like this would have been most susceptible to weathering so it is unlikely they would have been original. Today all four figures have been replaced.

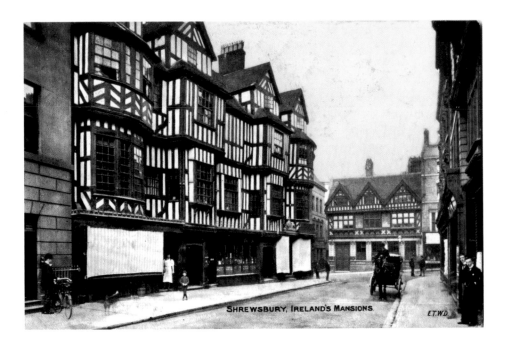

SHREWSBURY, IRELAND'S MANSIONS. E.T.W.D.

Ireland's Mansion

Again we have drawn blinds, which seems a bit unnecessary to me as this building faces north. Ireland's Mansion also dates from the late 1500s, a time when timber was becoming an ever more expensive and less readily available commodity. To see so much of it in this building and in Owen's Mansion in the previous photograph tells us that these houses were built by men of extreme wealth who wanted everyone to know they could afford such things.

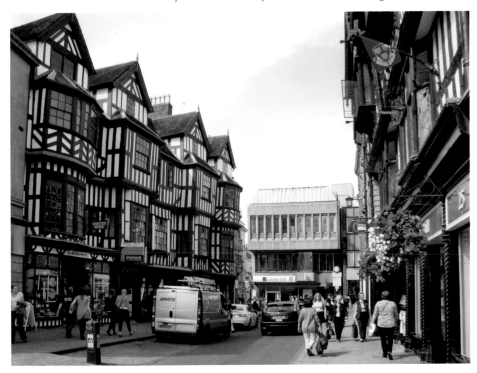

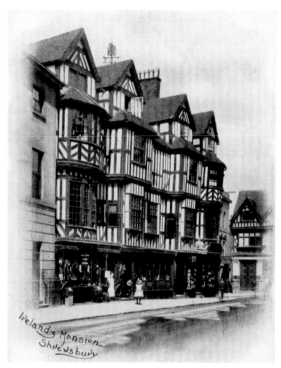

Ireland's Mansion

When it was first built this building was apparently known locally as Ireland's Folly, as everyone thought he had over-reached himself. However, Ireland was a wealthy merchant and he knew what he was doing. He built this new house in three parts – a Tudor terrace, if you like. The central part was a house for himself and on either side (the sections with the rounded upper windows) was another house that he then rented out.

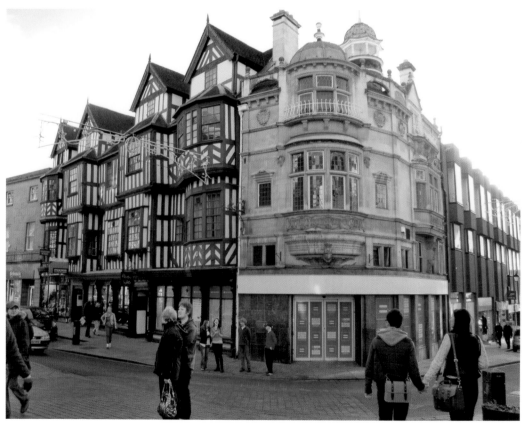

The Dun Cow Inn

Not all timber buildings in the town were built by wealthy merchants, although who knows? The Dun Cow on Abbey Foregate may have had cash from the Church to aid in its construction – it was probably built for the purpose of accommodating pilgrims visiting St Winifred's shrine at the abbey. A 'dun' cow is a brown cow and there are many pubs in the Midlands with this name. It recalls a legend of a cow that was given to poor folk in the Shropshire hills to provide them with milk. All was well until a wicked witch turned up to milk the animal – with a bucket with a hole in the bottom. Unable to fill the bucket, the poor cow eventually went berserk, running amok through the countryside until it was killed in Warwickshire.

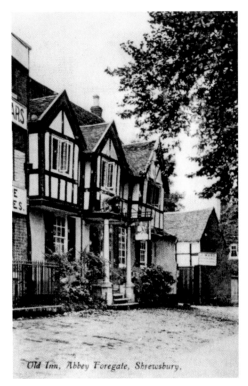

Old Inn, Abbey Foregate, Shrewsbury.

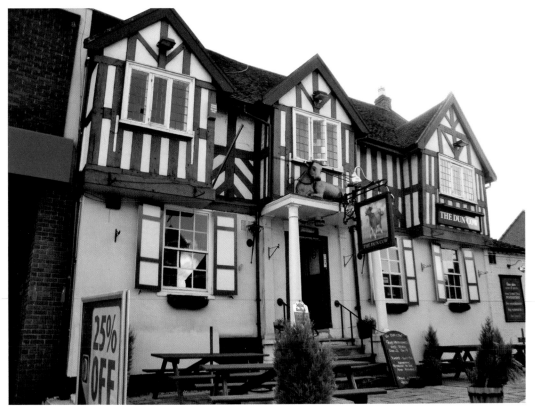

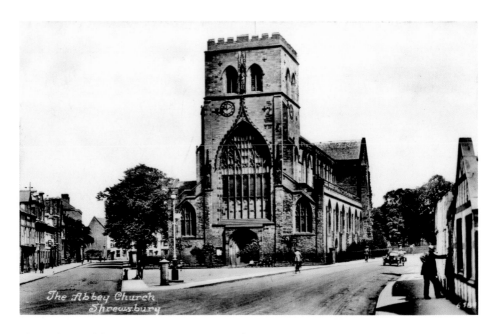

Shrewsbury Abbey

Like so many others, Shrewsbury Abbey was dissolved by Henry VIII, by which time it had become one of the wealthiest abbeys in England. This wealth was largely thanks to the many pilgrims coming to visit the shrine of St Winifred. St Winifred lived in northern Wales in the seventh century but her remains were brought to the abbey within fifty years of its foundation. Today all that survives of Winifred's shrine is one piece of stone on which it is possible to make out three carved figures, the central one of whom is assumed to be Winifred.

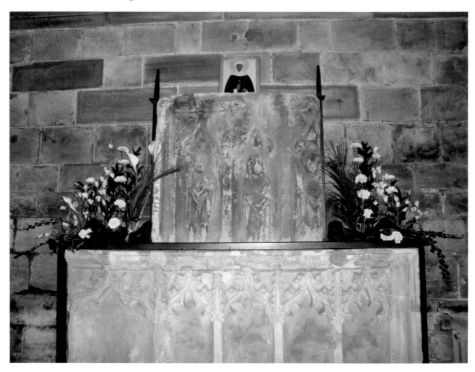

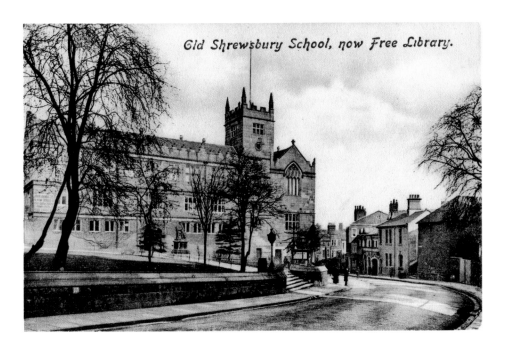

Old Shrewsbury School, now Free Library.

Old Shrewsbury School, Now Free Library

When Henry VIII dissolved all those monasteries, the schools associated with them were also lost. This left a vacuum in the education system, which was soon filled with schools such as this one, founded in 1552. Old boys at Shrewsbury School include Sir Philip Sidney, Bloody Judge Jeffreys and (most famous of all) Charles Darwin who is said to have hated every minute of his time there. However, at that time he was interested in the natural sciences – not a subject on the school curriculum of the day.

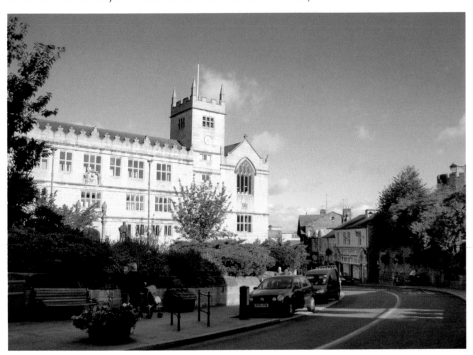

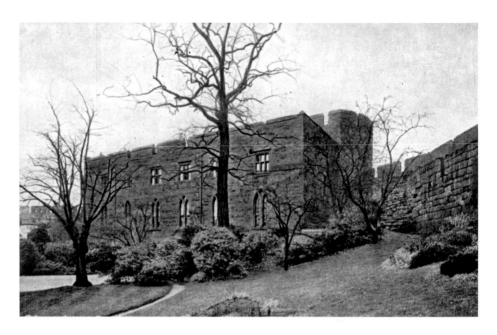

Shrewsbury Castle

With the unification of England and Wales, castles along the border became redundant and Shrewsbury Castle, therefore, became a private house, but peace didn't last for long and the seventeenth century saw the outbreak of civil war. By and large Shropshire people supported the Royalists and welcomed King Charles I when he visited the town seeking support (and money) for his cause. Following the King's departure, the people prepared to face attack and the castle was then refortified.

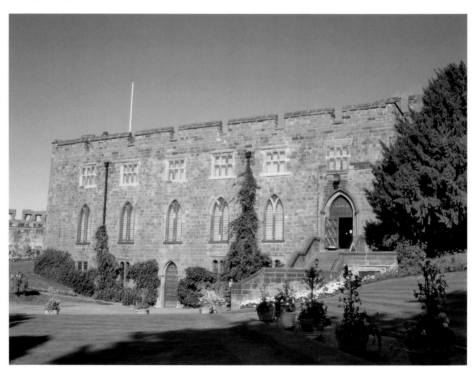

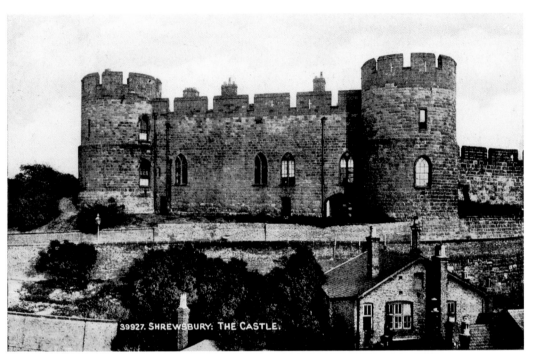

39927. SHREWSBURY: THE CASTLE.

Shrewsbury Castle

The attack came in 1644 and holes in the door are said to be bullet holes from that time. One local man, who supported the Parliamentarians, was Captain John Benbow and he led an assault on the town. Some years later, however, when King Charles was tried and executed, Benbow was so shocked by the regicide that he subsequently supported the Royalists. He was captured after the Battle of Worcester in 1651 and tried for treason, found guilty and executed by the entrance to Shrewsbury Castle.

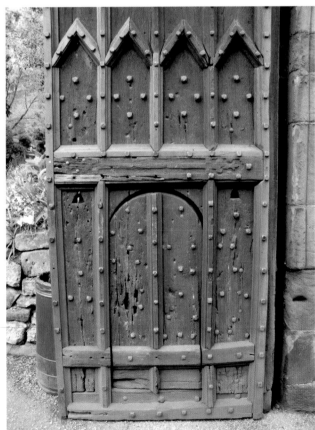

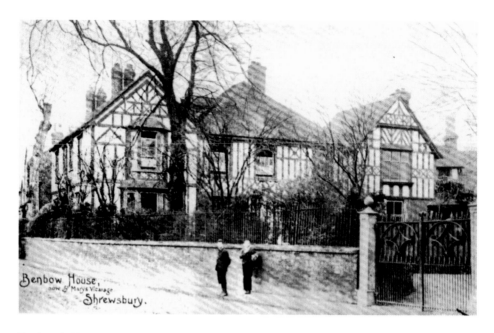

Benbow's House

Another Benbow, the captain's nephew in fact, lived in this house. This John Benbow joined the Navy and ended his life as an admiral, fighting against the French in the Caribbean. It is said that, when Admiral Benbow left Shrewsbury to go to sea, he placed his door key in a tree beside the house. He was away for such a long time that the tree grew over the key – it's still there on display in a cabinet in front of the appropriately named, modern Benbow's Quay apartment block. Note the pun on 'key' – this was also by the river where the boats docked.

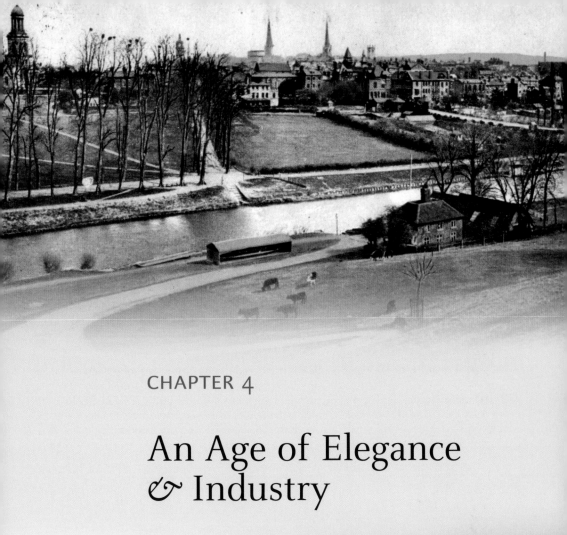

CHAPTER 4

An Age of Elegance
& Industry

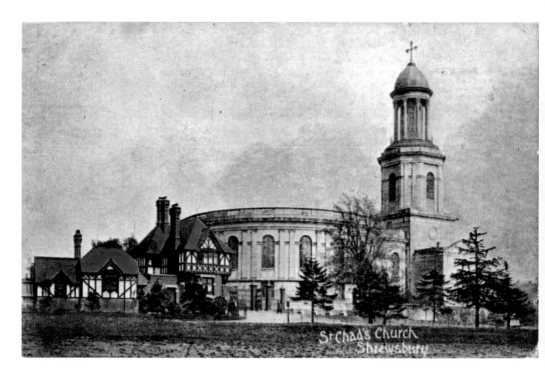

New St Chad's Church

There are two St Chad's churches in Shrewsbury. Only a small section of Old St Chad's survives, the main part of that church having collapsed in 1788. When this new church was built to replace it the Industrial Revolution was at its height and so new ideas were used in its construction including iron columns in its structure. It was here, in 1809, that Charles Darwin was baptised.

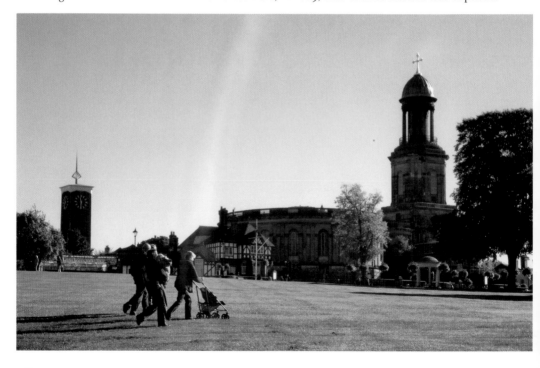

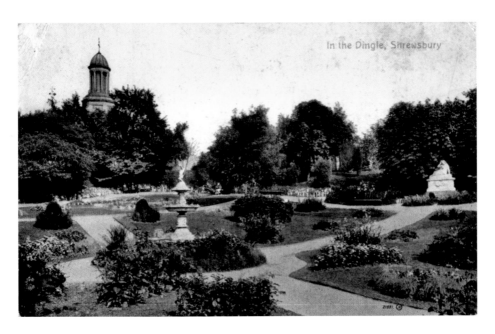

In the Dingle, Shrewsbury

New St Chad's from the Quarry Gardens

Shrewsbury is often described as 'the town of flowers' and this association goes back as early as the 1600s when Celia Fiennes visited the town. She travelled all over Britain writing a journal as she went and remarked in it on the beautiful gardens of Shrewsbury. It's said by some that Celia Fiennes is 'the fine lady on a white horse' in the nursery rhyme – her family was from Broughton Castle, near Banbury, and the rhyme is thought to refer to her travels through the country.

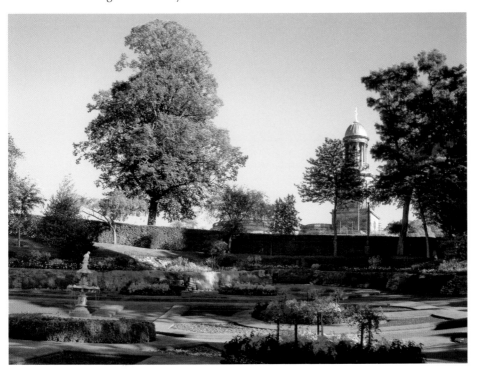

49

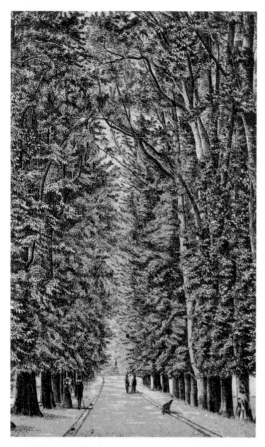

Avenue of Trees in the Quarry Gardens
Shrewsbury's Quarry Garden was one
of Britain's first municipal parks. It was
established in the early 1700s and within
a short time walks were laid out along
paths lined with lime trees. Over the years
these trees grew into perfect specimens.
Then, soon after the Second World War,
a new Park Superintendant arrived and
announced that the trees were nearing the
end of their natural life. The furious people
of Shrewsbury watched as all the trees were
felled. That Park Superintendent's name
was Percy Thrower.

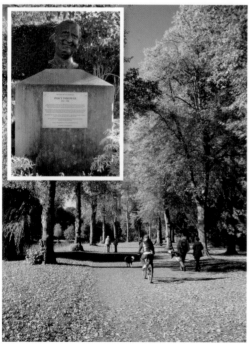

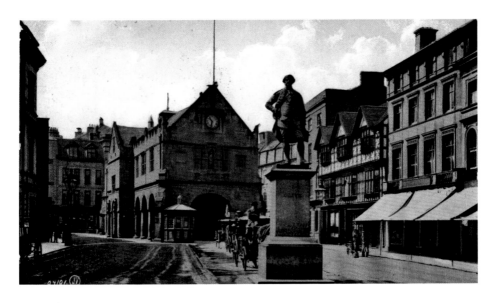

Clive of India

Today it is not fashionable to admire Robert Clive and his achievements in bringing the subcontinent of India into an expanding British Empire. Clive was born in Moreton Say in north-eastern Shropshire in 1725 and was still only in his teens when he arrived in India to work as a clerk with the East India Company. He now stands on his plinth in the Square not only because of his achievements in India but also because he subsequently served the town as both its mayor and in Parliament.

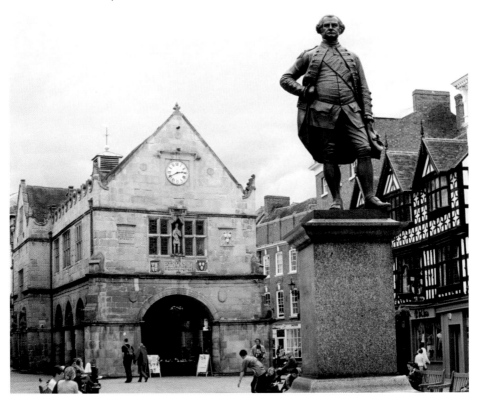

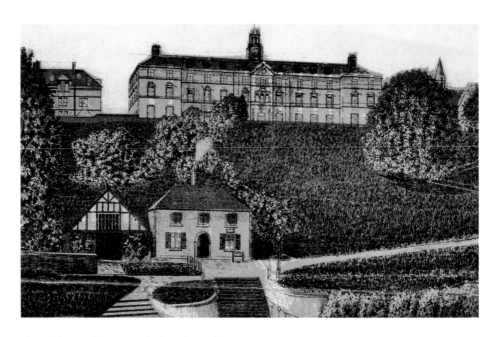

The Old Foundling Hospital and Workhouse

Shrewsbury School (as it is now) sits on a magnificent site in Kingsland, overlooking the town. Built in the 1700s the building initially served as a foundling hospital for children picked up off the streets of London and brought to Shrewsbury to be trained to work in the mills, here and in Lancashire. We are horrified today at such a situation but, at the time, it was seen as very philanthropic giving orphaned children an opportunity to find work and better themselves. The building later served as Shrewsbury's workhouse until it was taken over by Shrewsbury School in 1882.

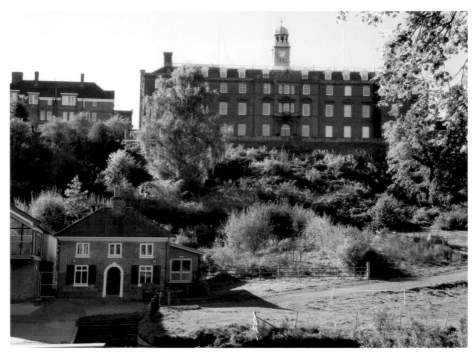

Lord Hill's Column

This is said to be the tallest free-standing Doric column in the world at 133 feet 6 inches (40.7 metres). On the top stands a 17-foot (5.2-metre) statue of Lord Rowland Hill who came to prominence in the first decade of the 1800s when serving in the Peninsular War. He was known to his men as 'Daddy' Hill because of the way he looked after their interests, and he was even trusted to look after them (and their dependants) should they be wounded in battle. In an age before pensions this was not the norm.

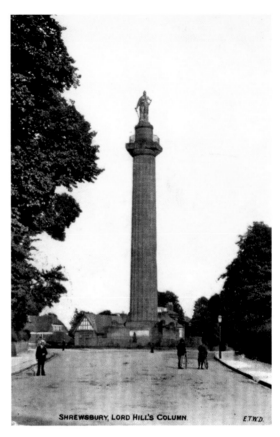

SHREWSBURY, LORD HILL'S COLUMN. E.T.W.D.

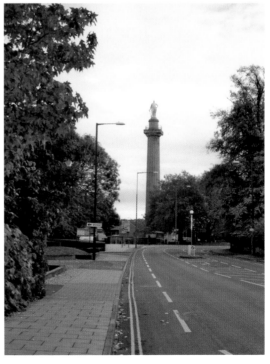

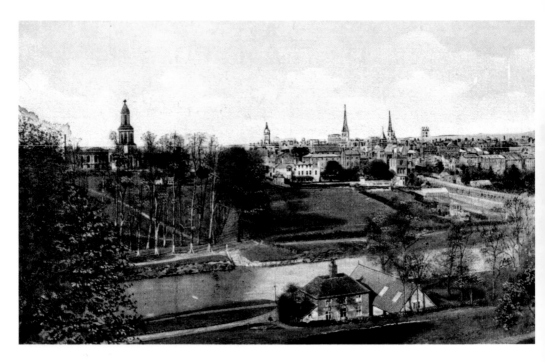

General View of Shrewsbury

It's only when you get up high above Shrewsbury (preferably on a balloon ride) that you can begin to appreciate what a wonderful site those early settlers chose when they came here. It is almost completely encircled by the River Severn with a gentle slope facing southwards that would, firstly, have been excellent for growing crops, and now provides a backdrop for the Quarry Gardens.

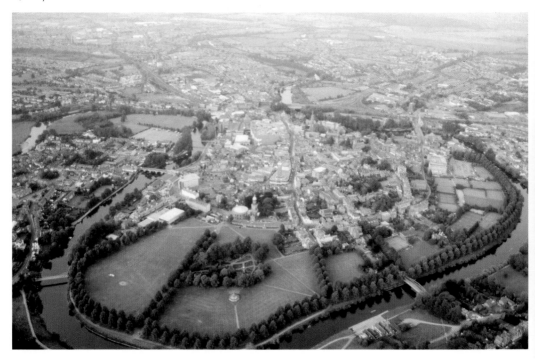

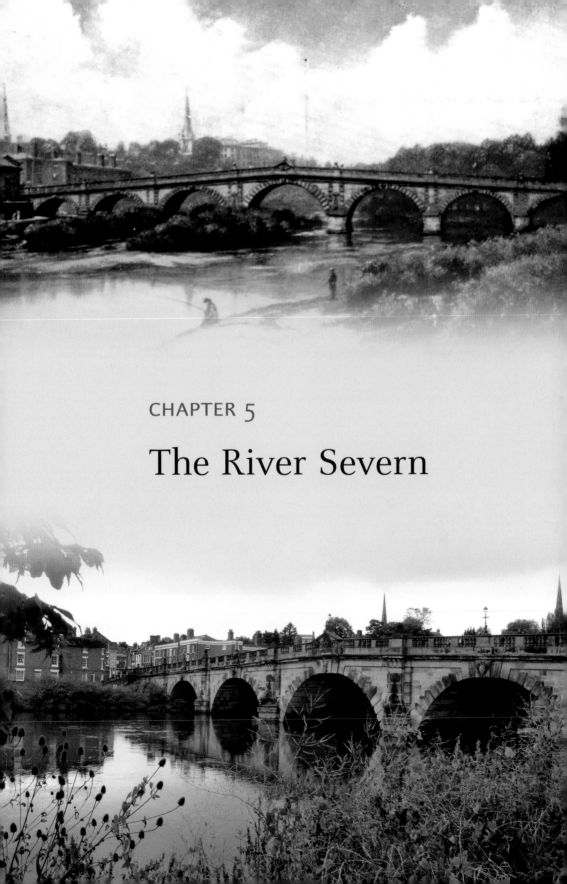

CHAPTER 5

The River Severn

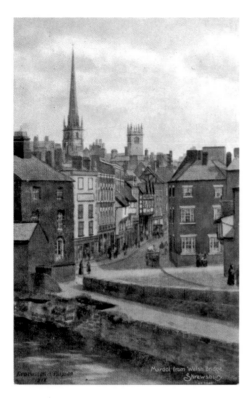

The View from the Welsh Bridge

Once the area where boats taking on or delivering goods would have docked, this is now a main road around the heart of the town. The curious sculpture on the left was erected in 2009 to commemorate the 200th anniversary of the birth of Charles Darwin in Frankwell, just across the river. It's known as *The Quantum Leap* but what is it exactly – the fossil of a dinosaur or a DNA strand? Or does it represent geological rock strata? Perhaps it is all of these things and many more besides...

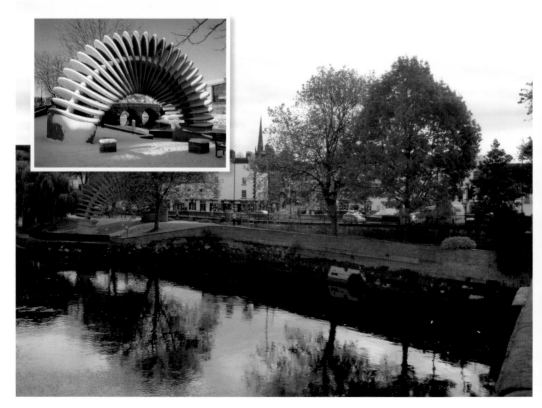

The Welsh Bridge

The first Welsh Bridge, known as St George's Bridge, was a medieval bridge with buildings and even a public toilet on it. This one was built in the late 1700s and when plans for it were first mooted, the engineer, Thomas Telford, warned that it was badly positioned and once it was built and the old bridge then removed, the river currents would be altered in such a way that they would seriously erode one leg of the new bridge. Telford's advice was ignored. Sure enough, a few years later repairs had to be made to the bridge to strengthen it in just the spot that Telford had indicated.

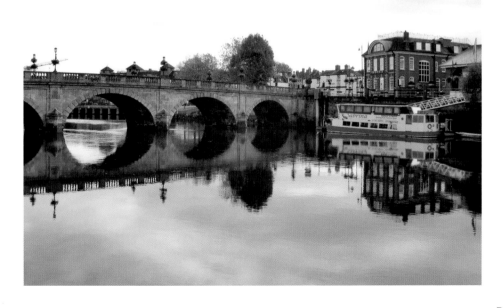

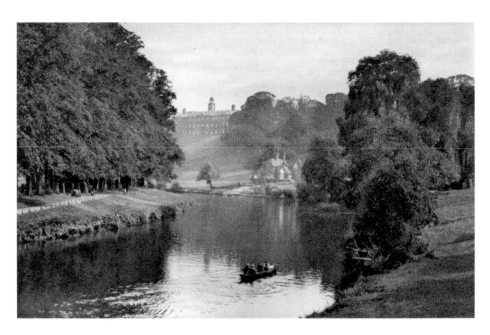

The View Towards Shrewsbury School

It wasn't just river currents that were dangerous along the Severn. The whole river used to regularly freeze over during the winter. On one occasion in the 1960s there were a number of local people skating on the ice when a policeman came along and told them to get off the ice because there were cracks appearing further upstream. 'Oh, that's alright,' said one of the group, 'the cracks are at Montford Bridge. It will take another twenty-four hours before they reach here.' And so they all happily skated on.

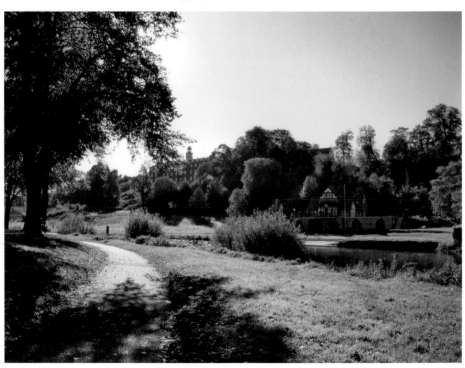

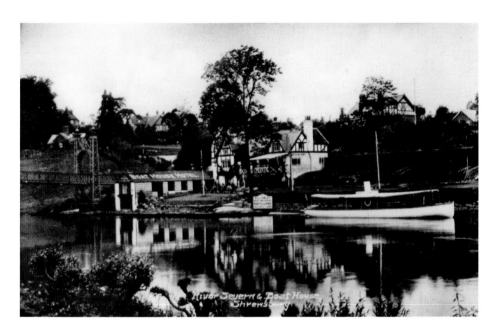

The Boathouse Pub

This peaceful scene has changed little over the years. It's a far cry from the days in 1650 when plague came to Shrewsbury. At that time, being safely beyond the town boundary, the pub was used as a plague house for St Chad's parishioners. In that year 250 people died in St Chad's parish alone. The pub is so named because it was originally used for boatbuilding; by the 1800s it was owned by a family of barge owners and so, inevitably, it became the haunt of hard-drinking bargees. The Porthill Bridge to the left was opened in 1922 and was paid for mainly by the Shropshire Horticultural Society. Before that date this was one of several ferry points across the river.

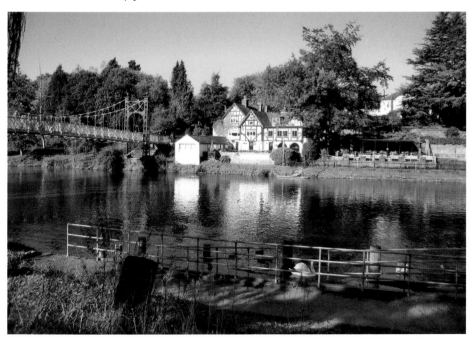

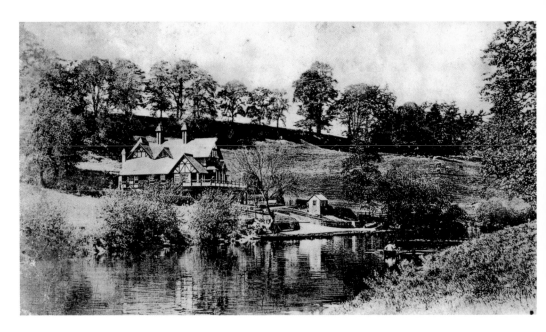

The Pengwern Club

The Pengwern Boat Club takes its name from the name of the capital of the Welsh kingdom of Powys in Dark Age times. The exact site of this early capital is unknown but many people believe that it was here, in Shrewsbury, although other contenders for the title include Denbigh, Wroxeter, Baschurch and Whittington. To make matters even more confusing, the present-day Welsh name for Shrewsbury is Amwythig.

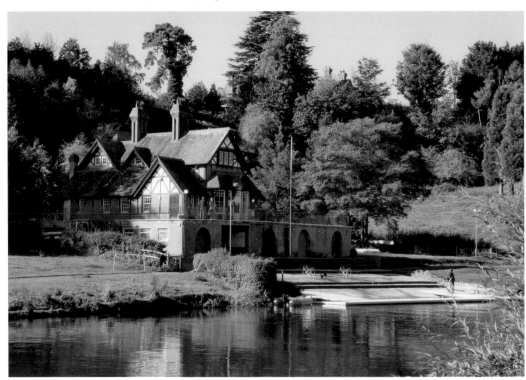

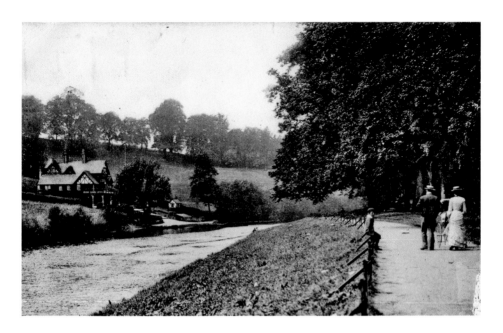

Walking by the River

The River Severn is one of three rivers that rise within a few miles of each other in the Plynlimon Mountains in Wales (the others are the Wye and the Rheidol). At 220 miles the Severn is the longest river in Great Britain and it flows for around 70 of those miles in Shropshire. Its Welsh name is the Afon Habren. *Afon* (which translates as Avon in English) simply means river and would have been a simple misunderstanding when early Saxon settlers in England asked local people what the name of a nearby river was – thus explaining why we have several River Avons in England.

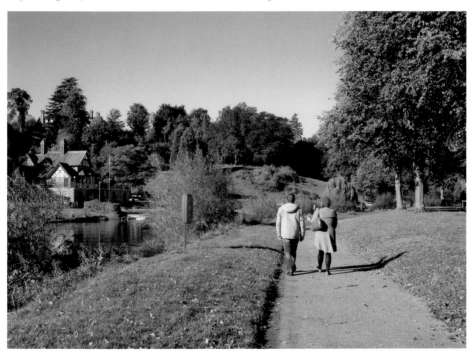

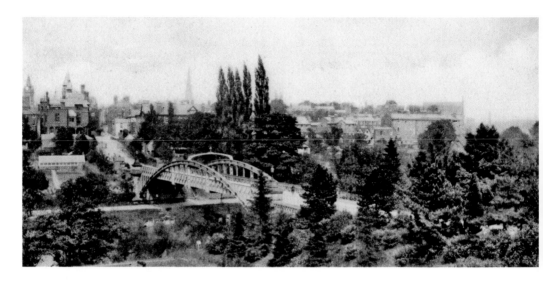

The Kingsland Bridge

In 1873 Parliament passed an Act allowing a bridge to be built linking Shrewsbury with the borough of Kingsland. There was a problem, however. The publisher of the *Shrewsbury Chronicle*, John Watton, was against the project, complaining that it infringed upon his cabbage patch and, using his paper, he was easily able to voice his complaints. It took seven years before another Act was passed and this one required that the bridge should be completed by 1883. In fact it opened in July 1882 (not 1881, as it says on the plaque) and on the first Sunday 1,500 people used it to visit Kingsland.

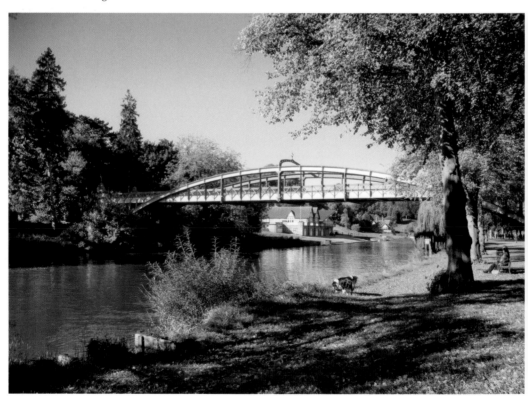

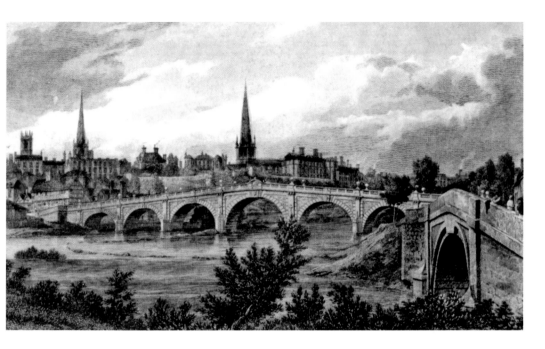

The English Bridge

Notice how the arch of the bridge is steeper in the earlier picture. This is not artist's licence. In fact, the bridge was dismantled and re-erected in the 1920s making it wider and giving it a lower angle. This is another bridge with an incorrect plaque. The plaque here tells us that it was Queen Mary who opened the bridge in 1927. It had been intended that the Prince of Wales should open the bridge but a death in the family meant that he cancelled the engagement – consternation. Then it was realised that the Queen had crossed over the bridge when on a private visit to the town not long before and so it was decided that that would be considered as the formal opening.

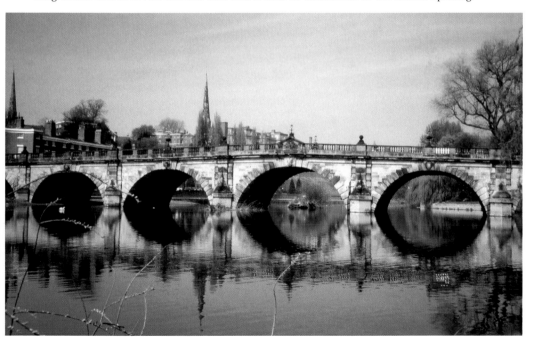

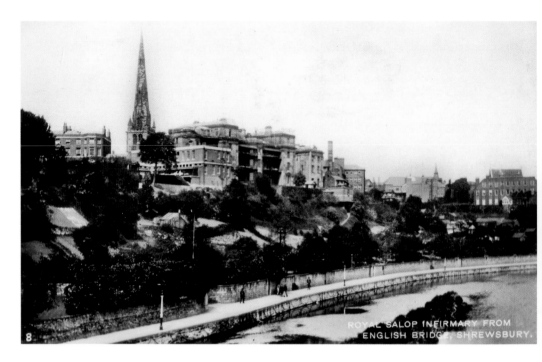

The View from the English Bridge

The large building just to the right of St Mary's church spire is the former Royal Salop Infirmary. Founded in 1747, this was one of the first public infirmaries in the country; this building, however, dates from 1830, and when it opened it was one of the first large buildings in the country to have a hot water central heating system. The hospital closed in 1977 and has now been converted to house a shopping arcade on two floors with apartments above.

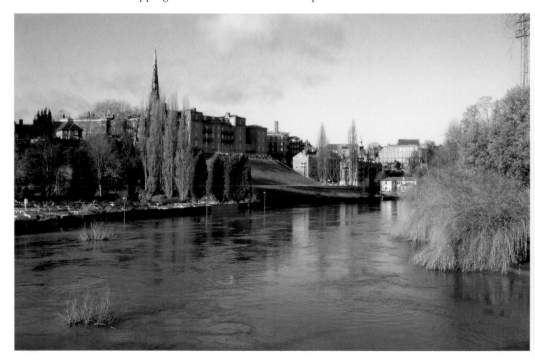

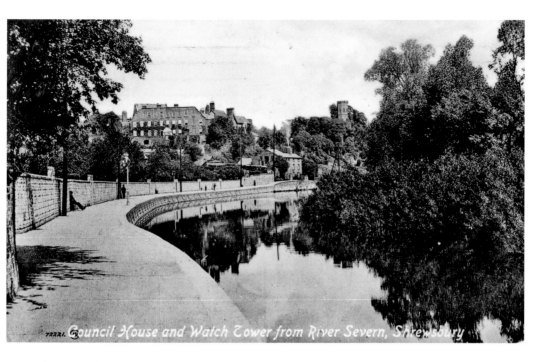

Council House and Watch Tower from River Severn, Shrewsbury

The Council House and Watch Tower from the River
A walk around the river is very pleasant but notice how high the water level is – the footpath is often closed due to flooding. The little watchtower in the distance is known as Laura's Tower. It never had any military function as it only dates from the late 1700s when it was built as a gazebo by Thomas Telford, who was then working on the refurbishment of Shrewsbury Castle.

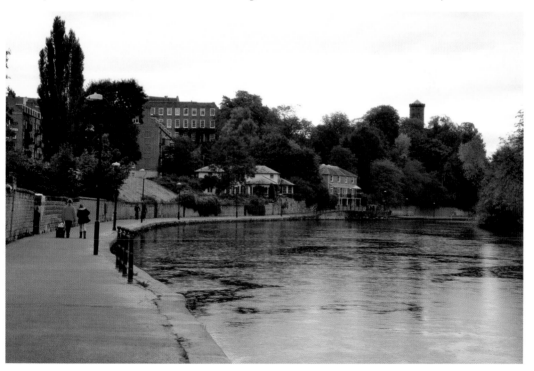

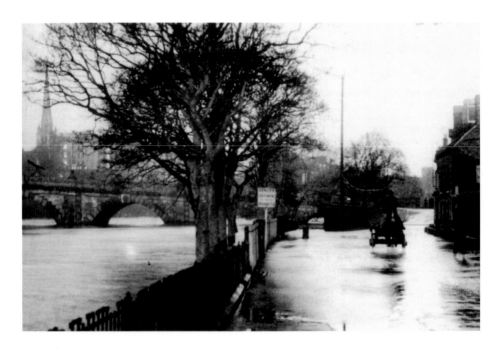

Coleham Underwater

Here we see just how high the floodwaters can sometimes reach. There are times when the only vehicular access into Shrewsbury is via the much higher Kingsland (toll) Bridge – tolls are usually suspended at such times. Flood defences have now been introduced to many areas where the river borders the town – it remains to be seen just how effective they all are when there is a serious flood.

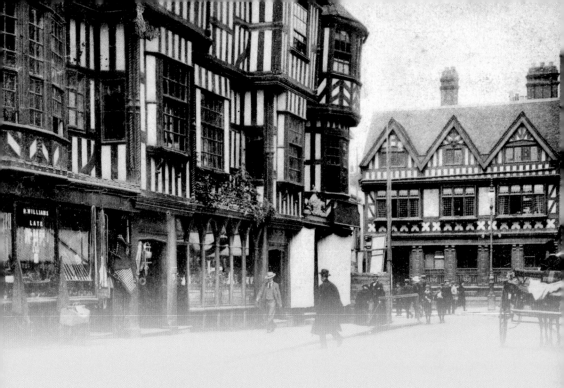

CHAPTER 6

Victorian Shrewsbury

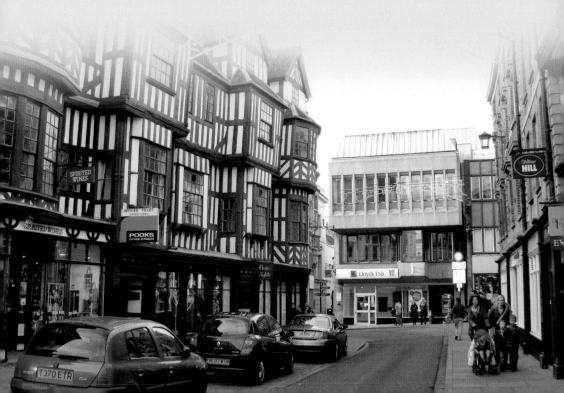

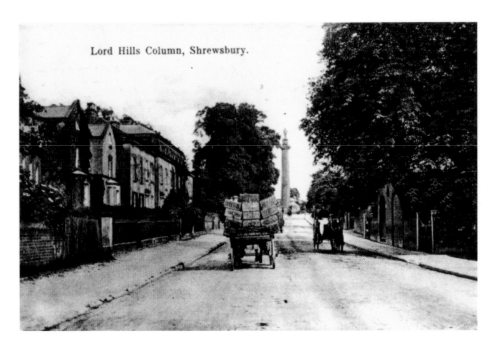

Lord Hills Column, Shrewsbury.

Abbey Foregate

In medieval times this would have been a country road leading from Shrewsbury in the London direction. As the town expanded in the nineteenth century this area was developed with properties not just along Abbey Foregate, as this road is known, but also in the suburbs behind. The most imposing buildings, however, were those that fronted Abbey Foregate, such as the row known as Column Buildings seen here on the left.

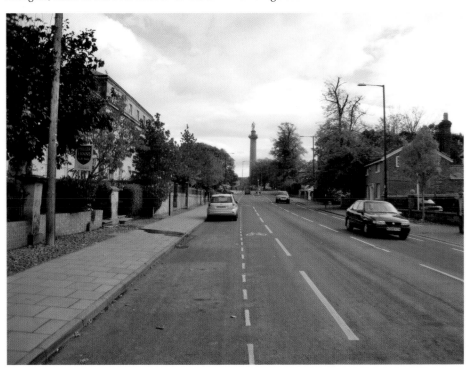

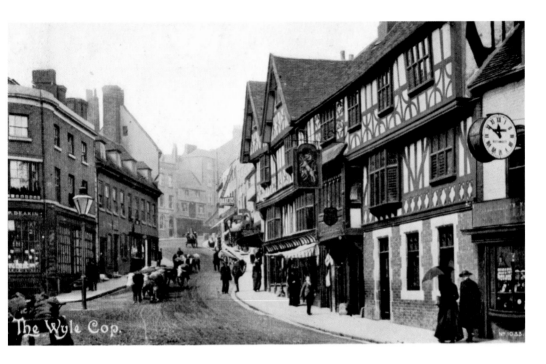

Wyle Cop Looking from the English Bridge

Notice the herd of cattle being driven down the road in the earlier photograph, which dates from the turn of the 1800s/1900s. The timber building on the right is a fortunate survival – today it serves as the home of Tanners Wine Merchants, and one of the shop's windows is the only surviving Victorian shop window in Shrewsbury. Internally the building is a delight, so much so that it was used as the backdrop for scenes from a 1980s production of the film *The Christmas Carol*.

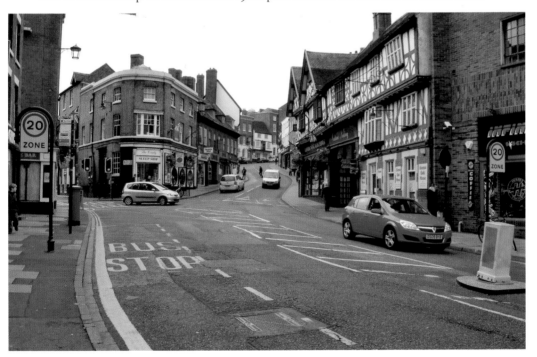

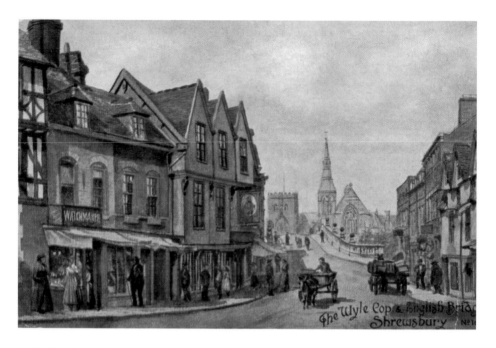

Wyle Cop Looking Towards the English Bridge

To take this photograph from the same position today would be to take one's life in one's hands. We are now looking in the opposite direction and can see, once again, just how steep the rise was on the English Bridge when it was first built. However, look just beyond the timber Tanners building on the left – all the buildings have been removed to be replaced by the entrance to a hideous 1960s car park.

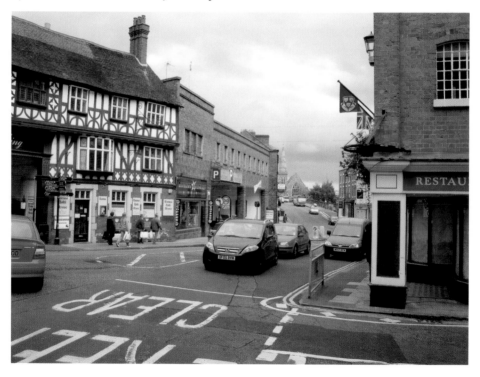

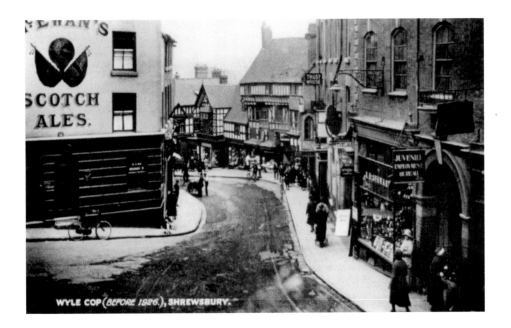

WYLE COP (*BEFORE 1926.*), SHREWSBURY.

The Top of Wyle Cop

Not only was the English Bridge widened for modern traffic in the 1920s but so too was much of Wyle Cop. Here, at the top of the hill, you can see that the Scotch Ales shop has been pushed right back. But notice how, in the present-day picture, the buildings further along on the left all look like genuine Georgian period buildings – this was an excellent example of where, although the fronts had been cut off, the buildings were restored in such a way that they fitted in with the general style of the town.

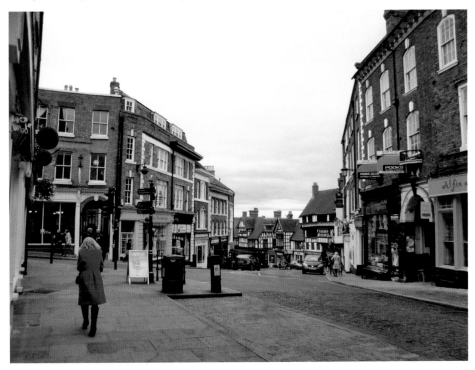

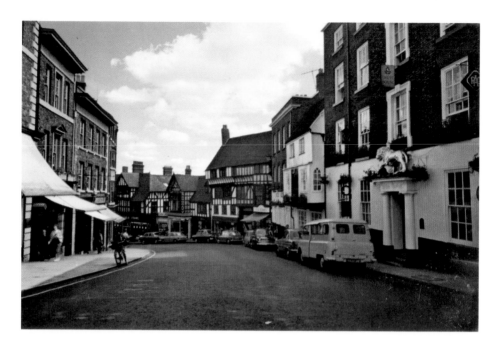

Wyle Cop Looking Downhill

Little seems to have changed since this 1960s postcard. The building on the right is the Lion Hotel and dates from the 1700s. In those days many hotels ran their own stagecoach service and the Lion was no exception. Its best-known stagecoach driver was a man named Sam Heyward of whom it is said that never, in his many years driving between Shrewsbury and London, was he more than ten minutes late reaching his destination.

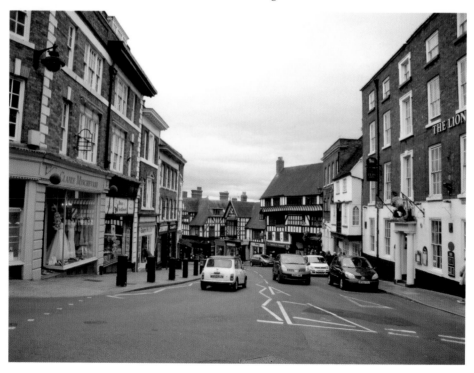

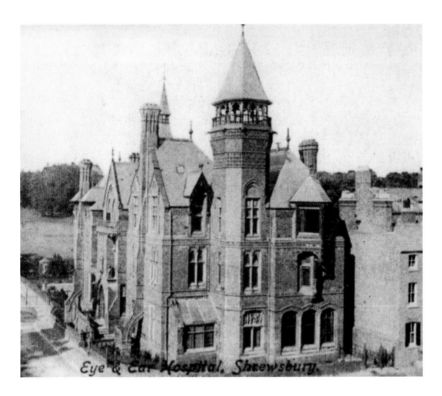

The Eye, Ear and Throat Hospital

The Eye, Ear and Throat Hospital was paid for by public subscription and opened in 1881. It's a wonderful example of Victorian architecture with a touch of the Gothic. It's also unusual in Shrewsbury in its extensive use of the bright red Ruabon brick. The building has now been converted into apartments.

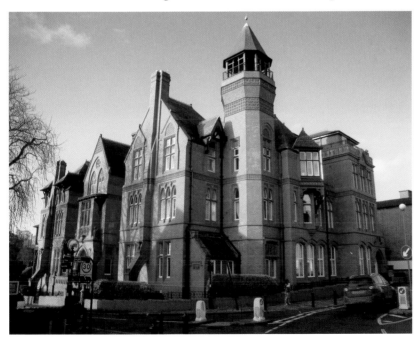

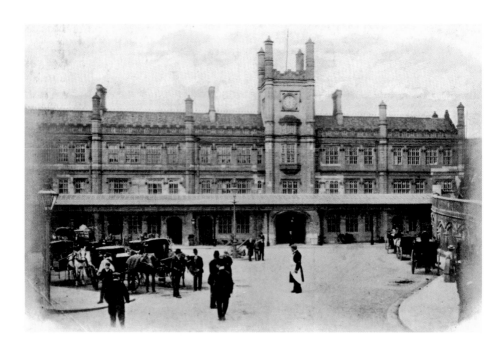

Shrewsbury Station

It was in the 1800s that the stagecoach was replaced by the railway. In 1848 the railway came to Shrewsbury and this station cost somewhere in the region of £100,000 to build. Originally it was a two-storey building with platforms at the other side raised artificially high. The reason for this was that to the east the line immediately crossed over the River Severn and the bridge for this line had to be high enough to allow barges to sail beneath.

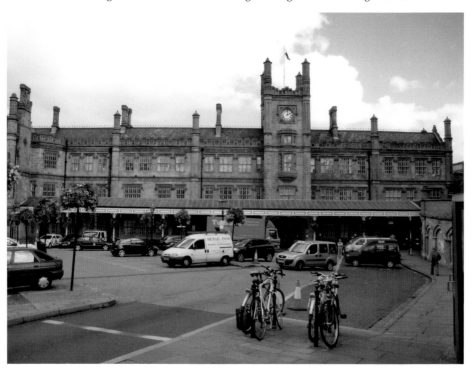

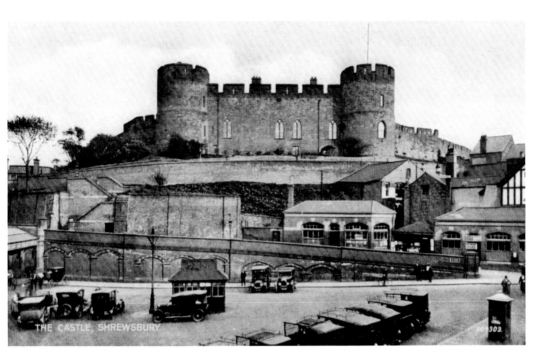

The Car Park at Shrewsbury Station

Fifty years after it had been built the station was extended downwards – earlier cellars were dug out and new foundations inserted below. The forecourt, also, had to be dug out to a depth of 12 feet to allow access. Notice in the selection of photographs on these two pages the changing modes of transport, from horse-drawn hackney cabs to modern cars and bikes.

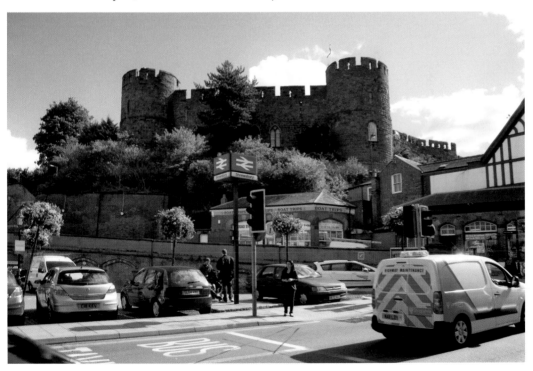

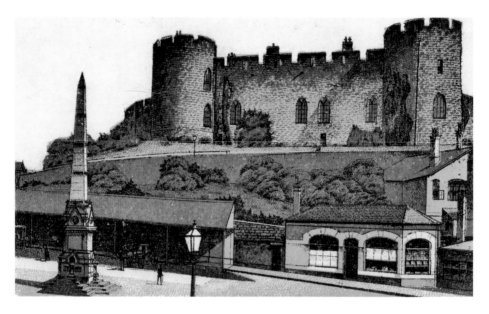

Shrewsbury Castle and the Clement's Monument

Comparison with the photographs on the previous page show that this picture was printed before the ground level was lowered and, in those days, the horses had a covered area in which to shelter. This covered shelter wasn't necessarily good for everyone – on one occasion there had been an extremely heavy snowfall and so a man parked his horse-drawn wagon under the shelter, out of the weather. However, this time the weight of the snow caused the shelter to collapse, killing the man as he sat in his wagon waiting for a fare. The man is said to have haunted the station area ever since.

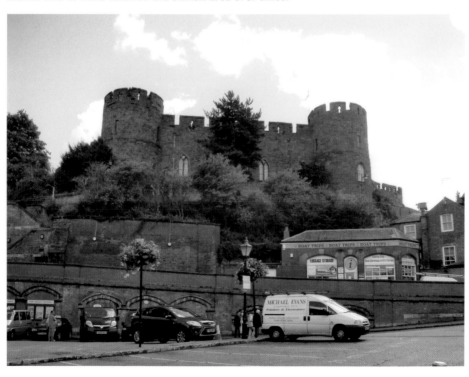

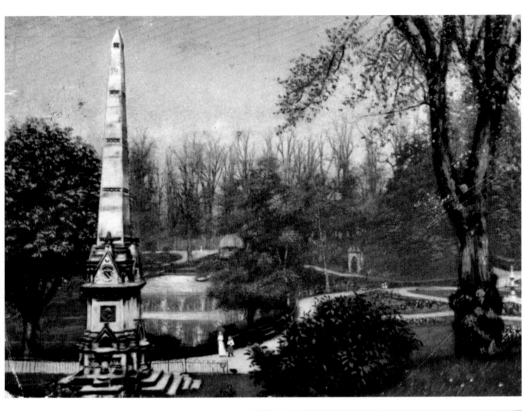

The Clement's Monument in the Quarry Gardens

Here we see the same monument but it's been moved to the Quarry Gardens. At least then it was in a prominent position. Nowadays it's tucked away, almost out of sight, forlorn and forgotten. Known as the Clement Monument, it commemorates William James Clement who died in 1870, having served the town both as a surgeon and as its MP with 'enlightened public spirit, consummate professional skill and active private benevolence'.

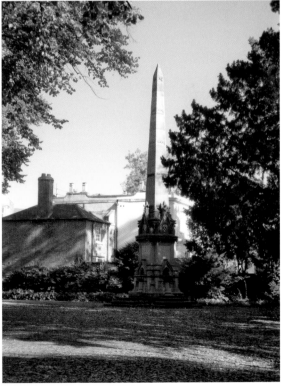

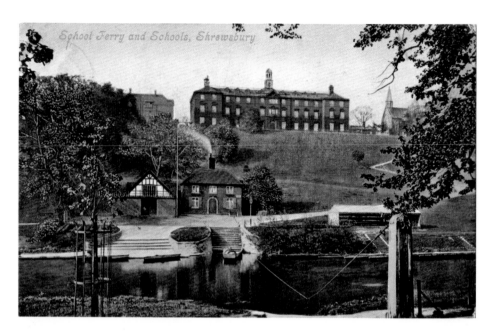

School Ferry and Schools, Shrewsbury

Shrewsbury School from the River

In the 1880s Shrewsbury School, having outgrown its old home in the heart of the town, moved to this site in Kingsland overlooking the river and the town. The former workhouse with 16 acres of land cost £8,000 and a further 10 acres was acquired from the town's Corporation. Ever since moving to this site the school has had a strong rowing tradition, the importance of which can be seen from the expansion over the years of the rowing facilities in the clubhouse on the riverbank. Notice the ferryboat and its rope. The post still survives today.

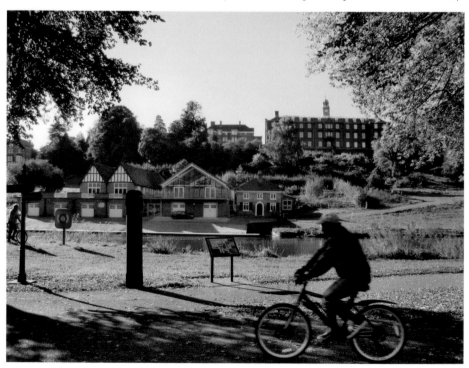

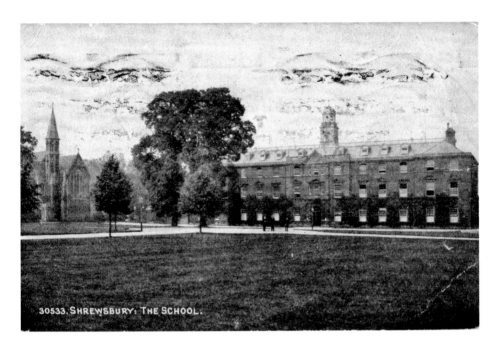

30533. SHREWSBURY: THE SCHOOL.

Shrewsbury School

Today Shrewsbury School is one of the top public schools in the country and many former schoolboys have become well known in their later careers. They include Michael Heseltine and Michael Palin, Richard Ingrams and John Peel, Nevil Shute and Willie Rushton, and many more. Of the roughly 720 pupils a proportion of those in the sixth form are now girls and there are plans to introduce girls into the lower age groups soon, too.

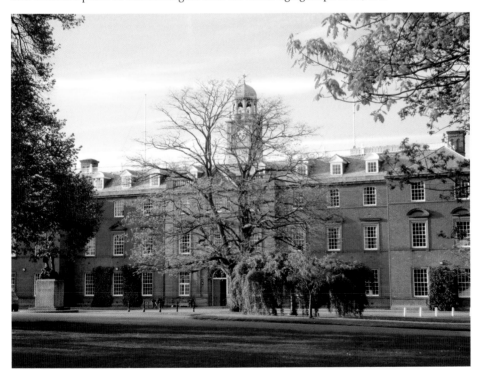

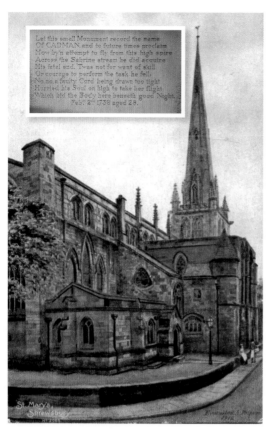

Let this small Monument record the name
Of CADMAN, and to future times proclaim
How by'n attempt to fly from this high spire
Across the Sabrine stream he did acquire
His fatal end. 'Twas not for want of skill
Or courage to perform the task he fell.
No, no, a faulty Cord being drawn too tight
Hurried his Soul on high to take her flight,
Which bid the Body here beneath good Night.
Feb: 2nd 1739 aged 28.

St Mary's Church

Little has changed in this view. In 1739, St Mary's church steeple was the scene of an accident. A tightrope artiste named Cadman was performing on his rope, which was tied to the steeple, when he fell to his death. There's a memorial to Cadman by the church door. When it was first put up a schoolboy from Shrewsbury School chalked up a postscript which read, 'Goodnight, goodnight poor Bob Cadman; you lived and died just like a madman.'

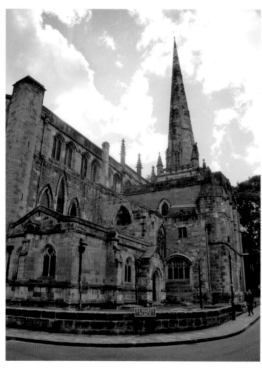

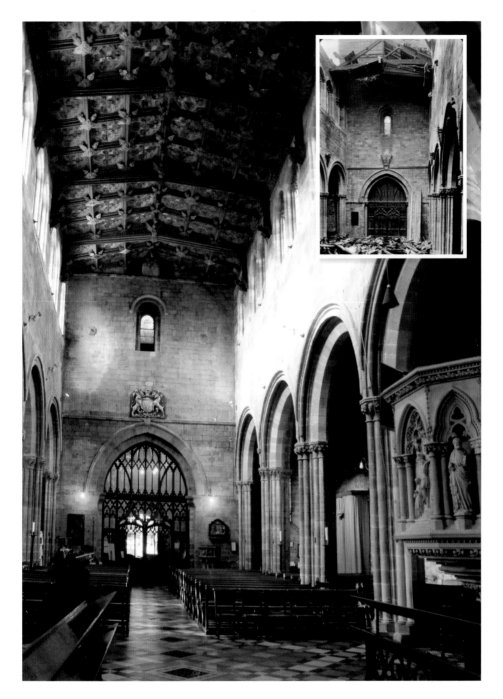

The Damage to St Mary's Church

Then, in 1894, there was another accident. This time the spire itself collapsed and fell through the roof of the nave. It so happened that the people of Shrewsbury were raising funds to erect a statue in honour of Charles Darwin at the time. The vicar of St Mary's disapproved of Darwin and his theories and so, the following Sunday, he preached a sermon denouncing the townsfolk and saying that the damage to St Mary's was a judgement on them for daring to honour such a man as Charles Darwin.

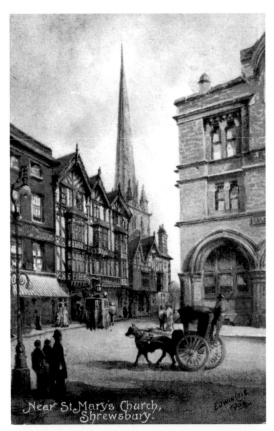

Near St Mary's Church, Shrewsbury.

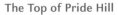

The Top of Pride Hill
The buildings may have changed but the name remains – the modern office block is called Crown House and this was the name of the timber-framed hotel that stood on the site beforehand. The building to the right has also gone – it was the town's post office but this has now been moved to the ground floor of a nearby shop. All that remains to tell us that there was once a post office on the site is the postbox standing nearby.

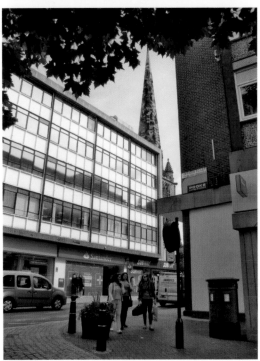

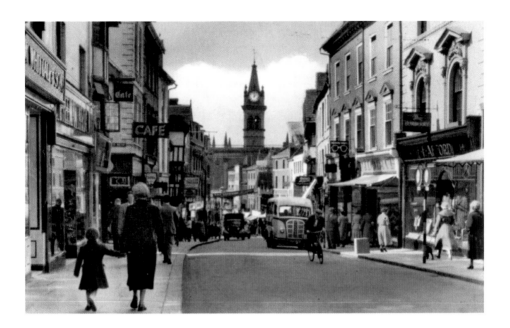

Pride Hill

Comparing these photographs as you walk down Pride Hill, the first difference you notice is that the old Victorian clock tower has been replaced. Many people in Shrewsbury deplore the replacement of the former market, even if the present one works better for those people who use it. Notice the decorative building (now Thomas Cook) on the right; much of the decoration is made of iron, although it's only when it gets rusty that people can tell.

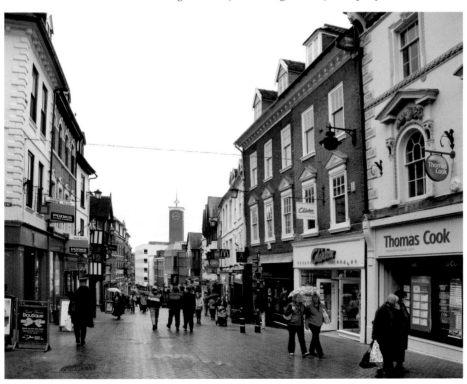

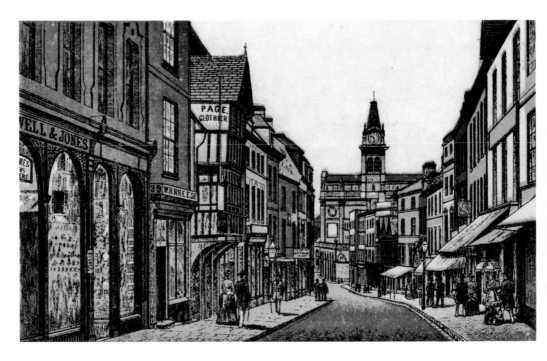

Pride Hill

Pride Hill is said to be named after a family that owned properties along the street in the thirteenth century. Not all timber buildings in Shrewsbury are old. The building on the far right of the earlier picture has been replaced by a mock-Tudor gabled building that dates from 1907, with an extra gable added just over ten years later. It is a branch of Boots.

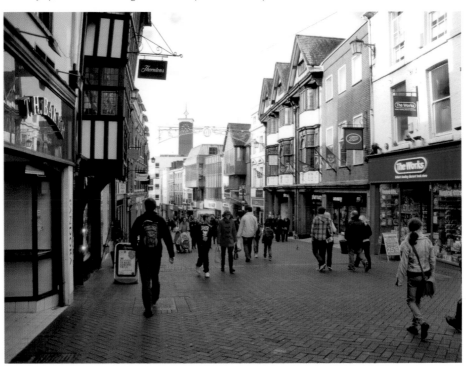

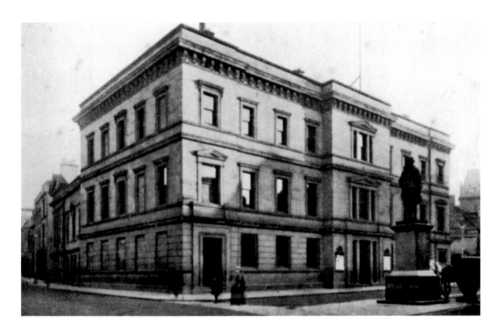

The Council House in the Square

Yet another building replaced in the 1960s. The area around Clive's statue was once an open market area in a slight dip in the land surrounded by higher ground. This meant that everything drained into it – rainwater, sewage, you name it. Not the most pleasant place in which to be dunked in a ducking stool! But it also meant that the land on which these buildings stand has never been particularly stable, and it was for this reason that the former Council House was demolished.

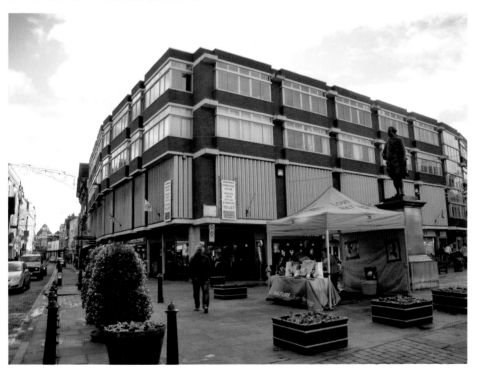

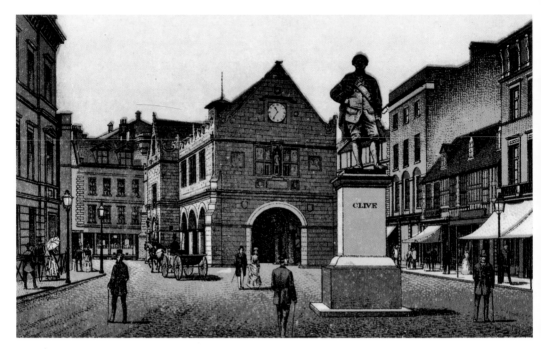

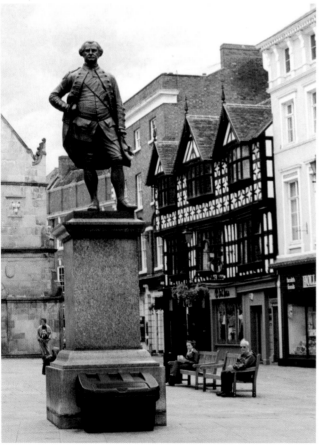

The Square

When I show visitors around Shrewsbury I often brag about how many towns in the country have fake (Victorian) timber-framed buildings whilst we have the genuine article here. I have to be careful where I stand when I say this because, as mentioned earlier, we do have our fakes, too. This building, until recently known as the Plough pub, is a mixture of both the genuine and the fake. Most of the building dates from Tudor times but the stop floor is a very clever addition added in the nineteenth century. It is only when you look closely at the timberwork and notice how much sharper the carving detail is on that top floor that you realise this.

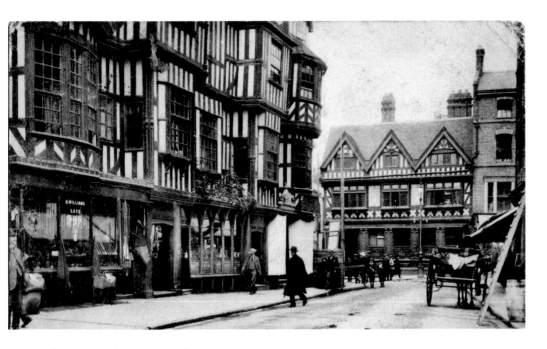

Ireland's Mansion and Lloyds Bank

Indeed, when I first arrived in Shropshire I assumed Ireland's Mansion (on the left) was a fake – it was large, it was in the centre of the town and, above all, it had survived. But genuine Tudor it is. The building at the end of the street was a fake, however, and was replaced in the 1960s. The new Lloyds Bank building won an award for its interpretation of the Tudor style – notice how each floor juts out beyond the floor below and also how the vertical concrete lines mimic those of the timber building.

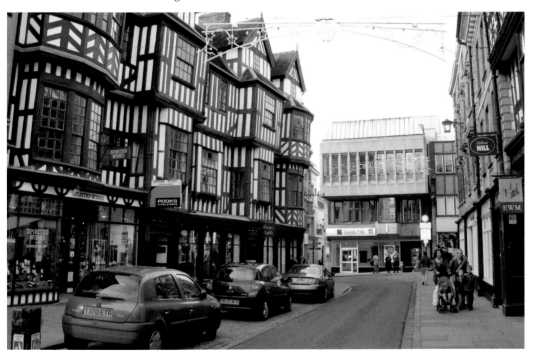

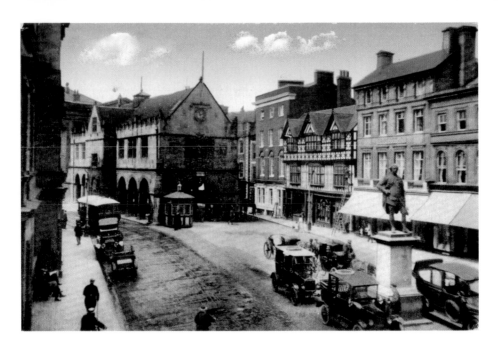

The Square – a General View

I've always liked this picture of the Square with the old 1920s cars lined up. Notice, too, the old omnibus parked to the left of the Market Hall. Near it is an odd-looking little structure that seems like a garden gazebo – it was a shelter for the cab drivers, some of whose vehicles presumably are parked beside Clive's statue. The cabbie's house survives – it now sits in the grounds of Shrewsbury Castle.

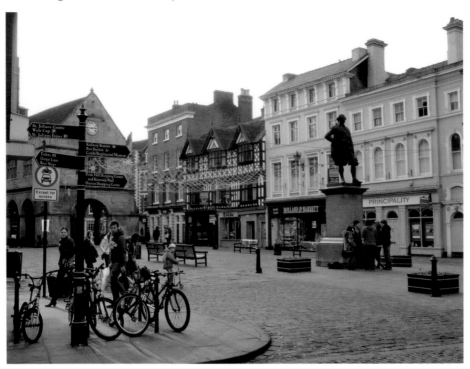

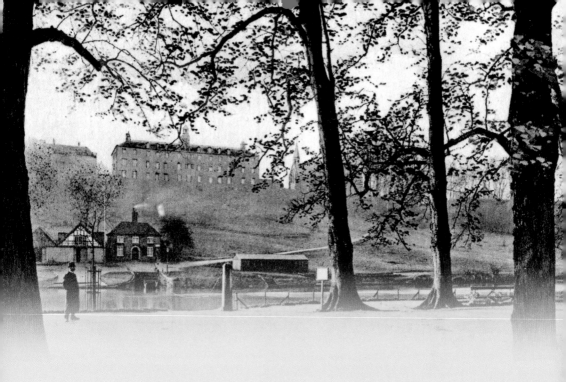

CHAPTER 7

Into the Modern Age

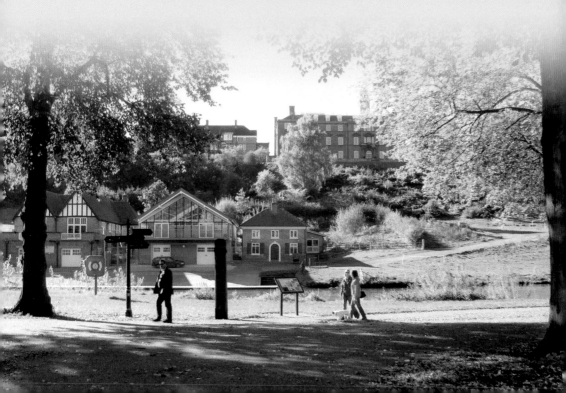

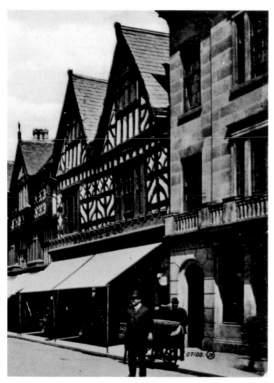

The Old Fire Office Building
Sometimes people do rather enjoy 'gilding the lily' when they take over an older building. When the building on the right became home to the Salop Fire (Insurance) Office just about every surface was ornately decorated.

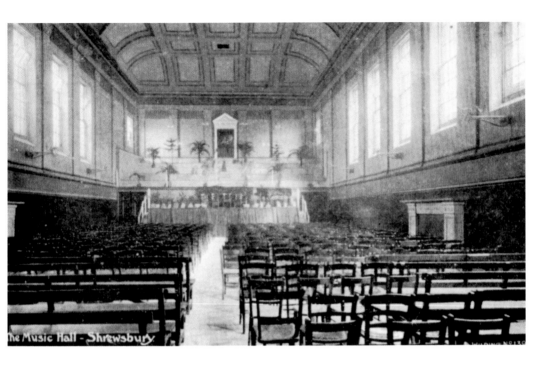

The Music Hall

As I write this the interior of the Music Hall is being transformed into a new museum for the town. The Music Hall dates from the 1830s but the building contains many much older elements, so that the very building itself will, in effect, be one of the items on display. The museum is planned to open in 2013. (*Bottom photograph: Sue Hall*)

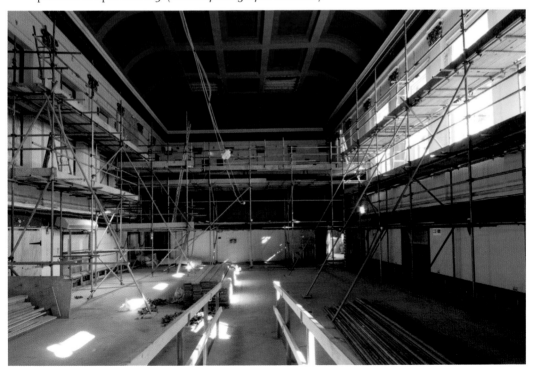

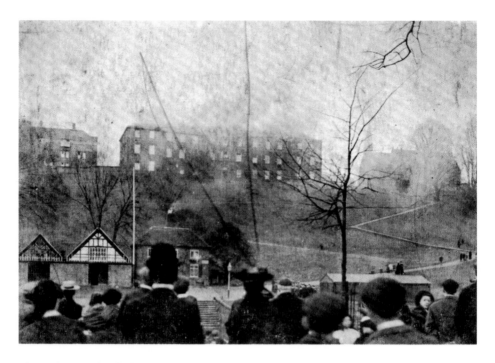

Shrewsbury School Ablaze

One advantage of having a postcard producer in the town was that, in the days before instant news on the television, news of big events, and many disasters, could be rapidly posted around the country in the form of postcards. One such example is this postcard showing a fire that broke out in Shrewsbury School on 5 December 1905. It spread rapidly throughout the building – this view shows the whole of the roof obscured by smoke – and caused the bell tower with its clock to collapse into the building.

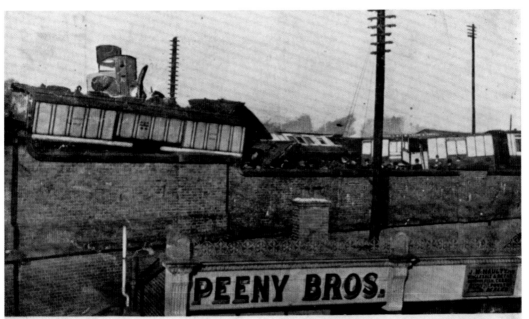

THE WRECKAGE OF THE L. & N.W. RY. EXPRESS AT SHREWSBURY, OCT. 15TH, 1907. 14

Train Derailment at Shrewsbury Station

Sometimes when you collect postcards the message on the back is far more interesting than the picture. So I make no excuse for including both sides of this card. Notice that the rail accident occurred on 15 October 1907. Not only does the message say something about the accident but the postmark shows that once the accident had been photographed the card was then printed, bought, written on and posted, all before 11 a.m. on the very next day.

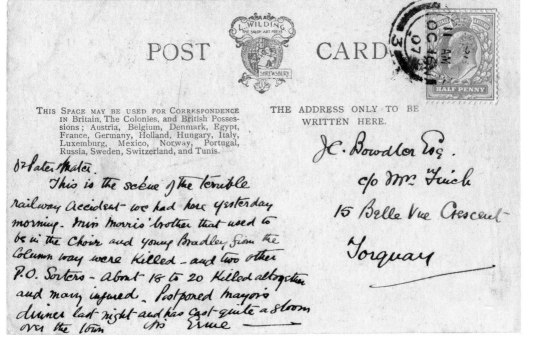

POST CARD

L. WILDING
THE SALOP ART PRESS
SHREWSBURY

HALF PENNY

THIS SPACE MAY BE USED FOR CORRESPONDENCE IN Britain, The Colonies, and British Possessions; Austria, Belgium, Denmark, Egypt, France, Germany, Holland, Hungary, Italy, Luxemburg, Mexico, Norway, Portugal, Russia, Sweden, Switzerland, and Tunis.

THE ADDRESS ONLY TO BE WRITTEN HERE.

Dr Pater Mater.
This is the scene of the terrible railway accident we had here yesterday morning. Miss Morris' brother that used to be in the Choir and young Bradley from the Column way were Killed – and two other P.O. Sorters – about 18 to 20 Killed altogether and many injured. Postponed mayor's dinner last night and has cast quite a gloom over the town Erine –

J.C. Bowdler Esq.
c/o Mrs. Finch
15 Belle Vue Crescent
Torquay

93

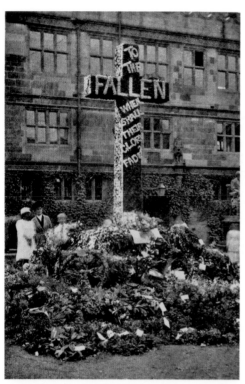

Salopia Never Forgets

This postcard is titled 'Salopia never forgets' and this is typical of memorials erected all around the country in the years immediately after the end of the First World War.

In the background is the town's library. Subsequently, more permanent memorials were commissioned so that Shrewsbury's main memorial stands in the Quarry Gardens. It was built of Portland stone in 1923 and shows a bronze figure of St Michael the Archangel, who is generally considered to be the field commander of the Army of God and the patron saint of warriors.

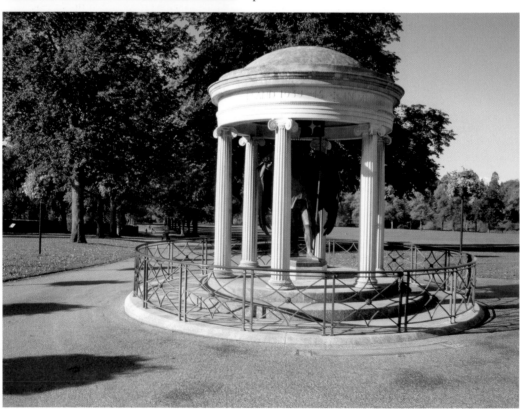

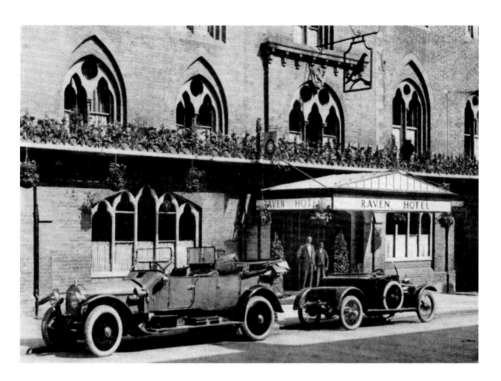

Entrance to the Raven Hotel

I do so love the pictures with beautiful old cars. The Raven Hotel in Castle Street was used during the Second World War by the American Red Cross as a club for American servicemen. It was run by an American colonel who ruled the place with a rod of iron, so that it was one place where nice girls could be seen without losing their reputations.

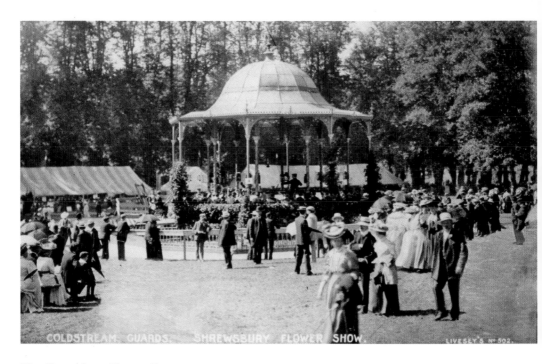

The Shrewsbury Flower Show

In 2012 the 125th Shrewsbury Flower Show was held in the Quarry Gardens. Allowing for gaps during both the First and Second World Wars, the Shrewsbury Flower Show is one of the oldest in the country, if not the world. The shows are organised by the Shropshire Horticultural Society and the earliest references to both the show and the society can be traced to a carnation and gooseberry show that was held in the town in 1836.

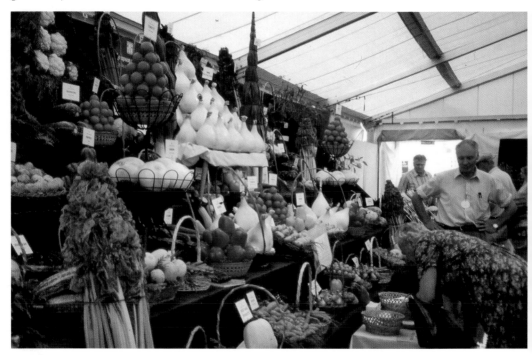